ambroise tézenas

I was here

DEWI LEWIS PUBLISHING

When I arrive in Oswiecim at the end of the day it is raining. Night is falling, it's winter, the shock is brutal. A sign reads: "Forever let this place be a cry of despair and a warning to humanity, where the Nazis murdered one and a half million men, women, and children, mainly Jews from various countries of Europe."

To see it is to remember, to gather one's thoughts, 'lest we forget'. At Auschwitz the goal is certainly clearly understood by most visitors, but is the phenomenon of mass tourism compatible with this need for awareness? In the area surrounding Auschwitz, hotels and car parks are sprouting up and competition between the Krakow tour operators is a reality. The clash is disturbing. "Auschwitz? A return ticket? From the city centre? Yes it's possible."

The following evening, I dine with Pawel Sawicki, press officer at the Memorial, who gives me permission to photograph the site using a tripod. I timidly broach the notion of 'dark tourism'. "The only important thing is that people come here, one doesn't come out of such a visit unscathed," he says. The risk that the message might be distorted obviously exists, but it doesn't matter that the Auschwitz Memorial may be associated with 'dark tourism'. This doesn't shock him. I am amazed by his uninhibited response and often think back to it during my travels.

A few months earlier in 2008, I had come across an article about macabre tourism in Sri Lanka. On 26th December 2004, a train known as the Queen of the Sea and which linked Colombo to Galle, had been swept away by a tsunami near the village of Telwatta. Since then, the train has lain in the jungle; a place of pilgrimage for some, one of curiosity for others. I wondered about the different motivations of these visitors. What would the victims have thought of it? What did the survivors think of it? Indeed, this dramatic event had a particular resonance for me. On holiday in Sri Lanka at that time, I had been a direct witness to the horror. I had found myself with a shirt tied around my face to alleviate the very real smell of corpses scattered throughout the jungle. Fear of an aftershock also saw me running as fast as my legs would carry me to high ground whilst the terrified Sri Lankans climbed into trees. The tears of the survivors are still etched in my memory and the idea that this place could become a 'photo opportunity' put me ill at ease. And I wondered whether, under the guise of an examination of conscience, we had not simply become consumers in a market of human barbarity? The explosion of mass tourism, which always calls for new offerings, may perhaps be responsible for this heightened attraction to the macabre, an attraction which hides itself behind the mask of culture, or even ethics.

Chernobyl, Ukraine. Prypyat – a ghost town in the middle of the forest. A lost city of our recent history, which still exudes a sense of apocalypse. There are those who want to turn it into a museum, a relic of the Soviet era. At the end of the day the school there has an air of incredible sadness, children's notebooks still on the tables, forgotten shoes. The town of Prypyat has something else surprising. Tourists. A group of eight, Swedes and Americans, cameras over shoulders, hands in pockets. In front of the reactor, while the discussion continues, a woman says "We have to go now, I'm afraid". The search for an adrenalin rush is evident, you feel the drama here, you become the first witnesses. The visitors treat themselves to a thrill, a dizziness, perhaps also a wish to reassure themselves, to avert misfortune by seeing how much better their own situation is.

The contrast between the glaring poverty of these places and these Western tourists strikes me. Since 2006, and the end of the obligatory visa for foreigners, visitor numbers have continued to grow. "You want protection against radioactivity? Have vodka," and here I am alone with my guide in the centre of Prypyat at the end of the day downing shots of vodka in one gulp. Humanity has humour. I sleep in Chernobyl, in a hotel, pristine white inside and made of sheet metal. There is no moon, the night is dark, there are no street lights and, above all, not the slightest noise – the end of the world.

Here, we come to confirm the truth of a nightmare.

Ambroise Tézenas

3

Auschwitz-Birkenau State Museum – Poland

For five long years the name of Auschwitz aroused fear among the populations of the Nazi-occupied territories. It was established in 1940 for the Polish political prisoners. Originally it was to be an instrument of terror and exterminations of Poles. As time passed, the Nazis began to deport to the camp people from all over Europe, mainly Jews – citizens of various countries. Soviet prisoners-of-war, Gypsies, Czechs, Yugoslavs, Frenchmen, Austrians, Germans and others were among the prisoners of Auschwitz. A few months after the end of the war and the liberation of the Nazi camps, a group of former Polish prisoners started publicly propagating the idea of commemorating the victims of Auschwitz. On 2 July 1947, the Polish Parliament passed an Act on the preservation "for All Time of the Site of the Former Camp". The task of the Museum is to safeguard the former camp, its buildings and environs, to gather evidence and materials concerning German atrocities committed at Auschwitz, to subject them to scientific scrutiny and to make them publicly available. In 2011, the Auschwitz Memorial was visited by 1 million 405 thousand people. This is a record number in the history of the Memorial.

(Source: Auschwitz-Birkenau State Museum in Oswiecim, Poland)

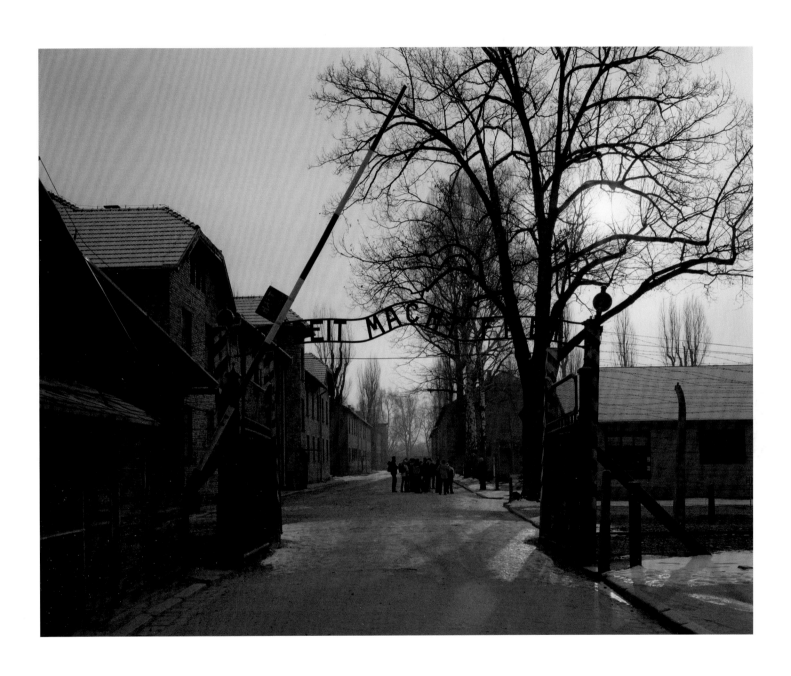

Auschwitz-Birkenau State Museum
Oswiecim (KL Auschwitz I). Main gate

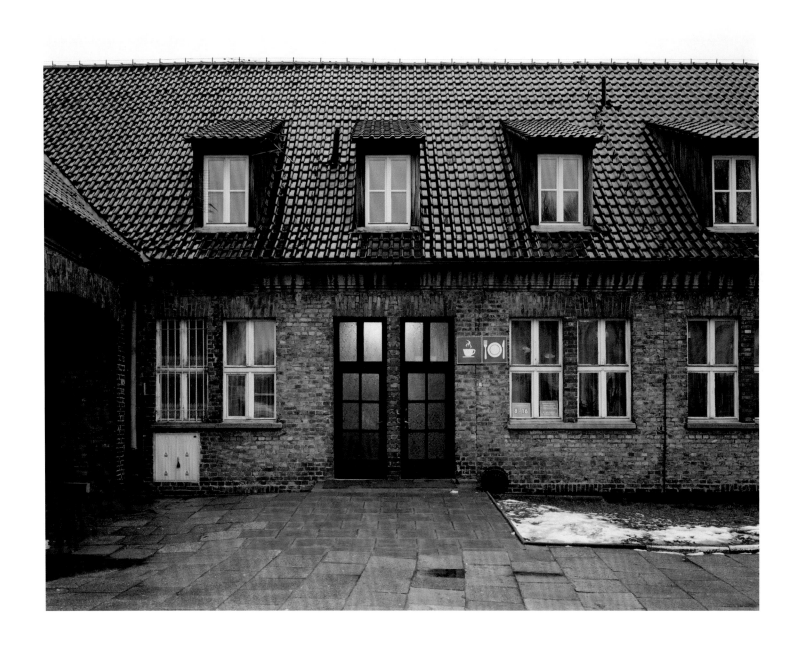

Auschwitz-Birkenau State Museum
Oswiecim (KL Auschwitz I). Cafeteria

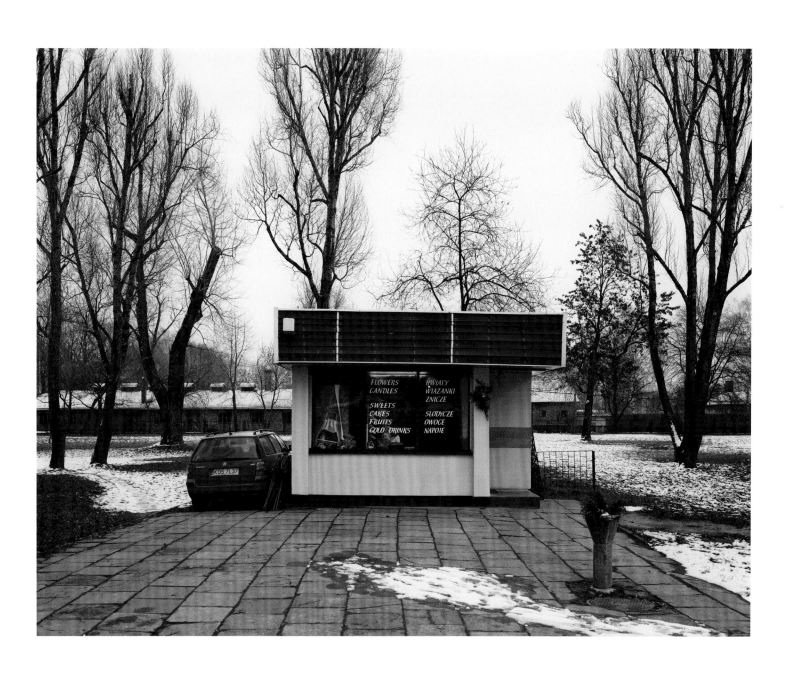

Auschwitz-Birkenau State Museum
Oswiecim (KL Auschwitz I). Parking

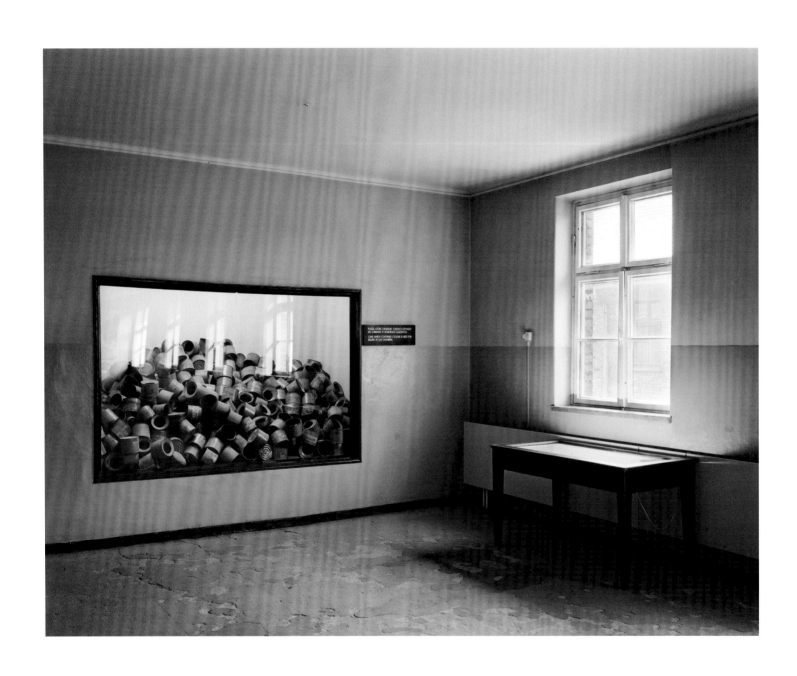

Auschwitz-Birkenau State Museum
Oswiecim (KL Auschwitz I). Block 4, Room 4
Cans which contained Cyclone B used for kiling in gas chambers

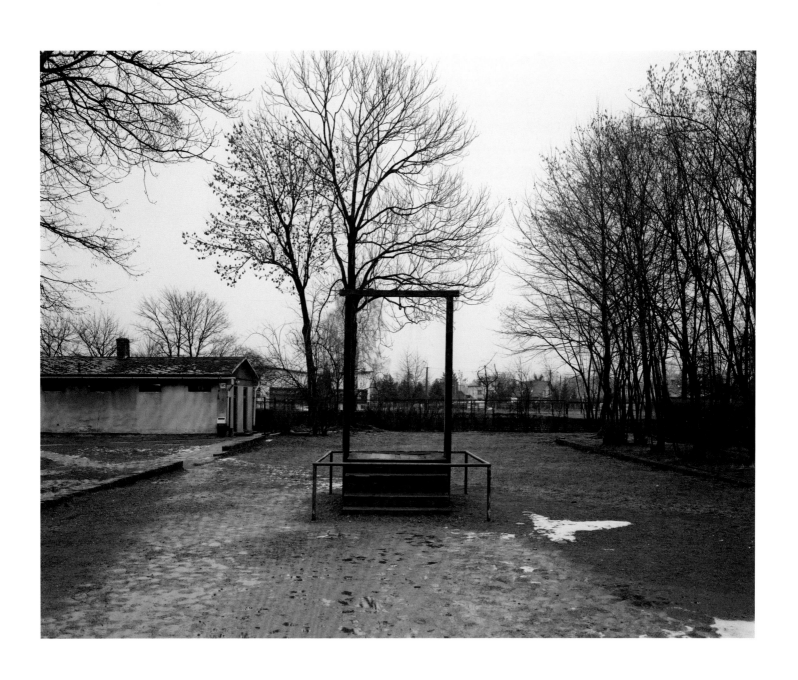

Auschwitz-Birkenau State Museum
The first commandant of Auschwitz, SS-Obersturmbannfürher Rudolf Höss, who was tried
and sentenced to death by the Polish Supreme National Tribunal, was hanged here on 16 April 1947

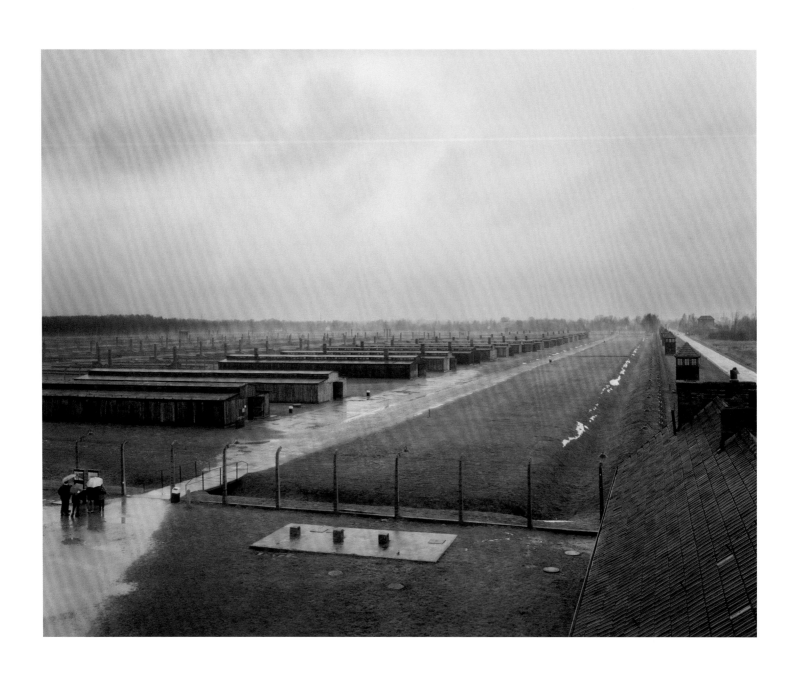

Auschwitz-Birkenau State Museum
Brzezinka (KL Auschwitz II - Birkenau)

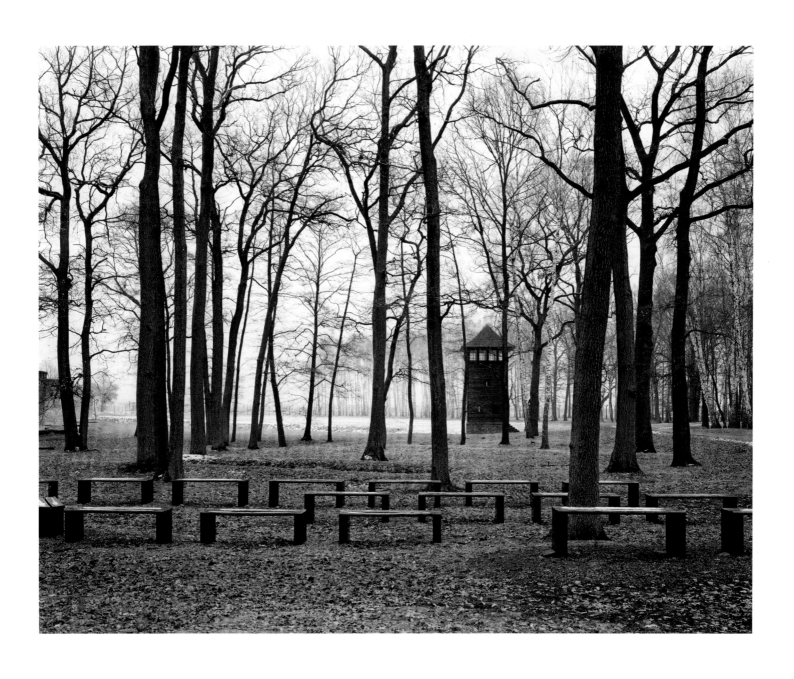

Auschwitz-Birkenau State Museum
Brzezinka (KL Auschwitz II - Birkenau)

Dark Tourism

The attraction of death and disaster

J. J. Lennon, Moffat Professor of Tourism - Glasgow Caledonian University

The fascination we have as humans with our ability to do evil, witness the evidence of horror and stare fixedly at photographic, filmic or artefacts connected with death, is at the heart of the phenomenon known as 'Dark Tourism'. In the locations and contexts photographed in this book the attraction is portrayed and the divided emotions of horror and fascination are illustrated in images from Rwanda to Poland. Crossing time scales and continents, the appeal of these exceptional images is at the heart of understanding such demand.

The work of Ambroise Tézenas explores this phenomenon in the most compelling visual record to date. Dark Tourism has become established as a specialist tourism focus for research and has been used to discuss the wider fascination we appear to have with our own mortality and the fate of others. Death, suffering, visitation and tourism have been interrelated for many centuries but the phenomenon was first identified and categorised by Lennon and Foley in 1996 as a major motivation for visitation. Further contributions to the area in academia include issues of interpretation, selective commemoration and cross-disciplinary study in the fields of the sociology of death/ death studies and in the area of criminology/ crime sites. What the research reinforces is that for many years humans have been attracted to sites and events that are associated with death, disaster, suffering, violence and killing. From ancient Rome and gladiatorial combat to attendance at public executions in London and other major cities internationally, death has held an appeal.

Dark tourism as a field has generated much more than purely academic interest. The term has entered the mainstream and is a popular subject of media attention. It is used as a marketing term and the appeal of a range of global destinations associated with dark acts shows no signs of abatement. More recently the enduring appeal has been reinforced in New York, Paris and beyond. The Ground Zero site now attracts significant numbers of visitors since the terrorist attacks of September 11, 2001. In Paris, the death site of Diana, Princess of Wales evidenced pilgrimage and visitation following her death and the site of her burial place – Althorp – achieved significant visitation. In Africa, sites in Angola, South Africa, Sierra Leone, and Rwanda have all demonstrated the appeal of dark histories and tragic events to visitors. The range varies significantly from Holocaust sites to the manufactured experience operations which recreate tableaux and 'historical' experiences. The motivation that impels expenditure in terms of travel, admission and other related costs compounds the proof of appeal.

This book of dream-like images presents a set of tableaux where we explore the fragility of life, shared human histories and our potential to exploit our darkest past and tragic events. To gaze at Tézenas' images is to confront those issues of visitation and observation.

The emotional attraction is neither new nor culturally straightforward. This is more than reflective memory for the viewer or visitor. This type of visual record – photographic, guided tour, and visitor attraction – remains critical to the historical record, memory prompt and documentary record. These melancholy photographic records of incarceration and execution contrast with the simulation experiences and voyeuristic appeal of natural disaster sites.

The subject matter was always intensely visual – from the detritus of concentration camps to the ceaseless parade of Khmer Rouge executed prisoners (recorded as an essential part of an industrial scale killing operation). The nature of the photographic composition should not detract from an endless, repeating spectacle that crosses continents, races and cultures. Death and tragedy are the constants that reaffirm how little is learned from atrocity as its familiar repetition in Poland, Bosnia and Rwanda illustrates. Such sites present complex problems in interpretation; there are major problems with the language utilised to adequately convey the horrors of some of these sites. The brochure copy that accompanies many of the images in this book testifies to the impossibility of description, the inaccuracy of history and the enormity of subject matter.

Consequently, and because of the presence of historical records, artefacts and buildings with dark heritage, visual representation is extensively used. Documentary evidence in the form of photographs is employed in sites of mass killing such as the Auschwitz complex at Oswiecim in Poland. Historical photographs and documentation of this nature have been central in transmitting the events of World War II, ethnic cleansing and numerous sites of tragedy or 'experience offers'. The visual heritage of these sites is rich; the railway lines of Birkenau, the rows of bones and skulls, watch towers, barbed wire, skeletal victims and mass graves. The importance of image in informing an appreciation of the historical reality has been discussed before (Lennon and Foley 2000, Lennon 2007). For example, the gates of Auschwitz are a globally recognised image associated with the Holocaust and the Nazi regime. However, the frequency of its use has served to diminish its impact over time. Interpretive photography within the Camp seeks to work in a more subtle way. At the railhead and main platform in Auschwitz II, is an example of how the use of photographs can help to demonstrate the historical reality of the location. The visitor looks from the documentary photograph showing guards and prisoners at the rail head (the past) to the present empty rails and platform and in this way the camera has had the impact of what Barthes titles "resurrection" (Barthes, 1981). The photographic image has the ability to transmit the reality of the death camps with immediacy and with an effect that words can rarely achieve. In this way the visitor can associate 'photographic time' with real time. In contrast, the recurrent use of pictures of the victims, mass graves and deportation trains can have the effect of an obsessive concentration and fascination that can blur into unreality (Lanzmann, 1995). Indeed, there is an inherent danger in constant recreation of the past, particularly if there is any attempt at manipulation or stylisation which can cheapen or trivialise the enormity of the issues being confronted. In this sense the image and resurrection effect deals with what Steiner titled 'the time relation'. This relates to the contemporary nature of Auschwitz in human culture and history and how incomprehensible that is. It appears as 'the other planet' to the one in which we live our everyday lives. In discussion of the victims of Treblinka, Steiner writes:

"Precisely at the same hour in which Mehring or Langer (victims of the camps) were being done to death, the overwhelming plurality of human beings, two miles away on Polish farms, five thousand miles away in New York, were sleeping or eating or going to a film or making love or worrying about the dentist. This is where my imagination balks. The two orders of simultaneous experience are so different, so irreconcilable to any common norm of human values, their co-existence is so hideous a paradox – Treblinka is both because some men have built it and almost all other men let it be..." (Steiner, 1967 pp.156-7).

This issue of reality and unreality and how we connect what Primo Levi referred to as the 'other planet' with our current existence is at the core of such visual representation. The issue of temporal and spatial affinity has been dealt with in a range of ways in other visual mediums yet the difficulty that rests with recounting something as enormous as the Holocaust or the massacres of Rwanda in narrative form will ultimately limit and distort representation. To abridge – to simplify to sentences is where the limitation of language is reached. Reconstruction and replication are flawed in this context. Their use for entertainment and commercial gain becomes questionable. The approach of Claude Lanzmann in the film *Shoah* is markedly different and merits consideration since it is closer to what the images of Tézenas seek to achieve. Unlike many attempts to film or televise the holocaust *Shoah* explores the legacy of the final solution by drawing the viewer into the debates of the original experience. This film focuses on the death camps of Chelmno, Belzec, Maidanek, Sobibor, Treblinka and Auschwitz, to reveal and document the genocide programme. It is not a historical documentary. Rather, Lanzmann conveys the full amazement of holding in sight an item (a tower, gate, the railhead) that came from 'the other planet' by the use of extensive interviews with victims, bystanders, perpetrators and survivors. In using contemporary 'real time' and interviews with perpetrators and linking this with long screen takes of camp sites, trains, rails etc., the connection between 'screen time' and 'real time' is established. In this way, rather than

providing didactic, historical narrative or Hollywood stylised narrative, the viewer is taken into the reality of the 'other planet' through this process of traumatic cultural shock. It ensures that the visitor or viewer is able to appreciate the full and dreadful aspects of this past (the other planet) by dealing with its symptoms in the present. Lanzmann denies the viewer the dubious privilege of being a witness, rather the viewer has to deal with more uncomfortable questions such as 'what does it mean to have witnessed it?' (Romney, 1995). In this respect, Tézenas' images offer the viewer similar dilemmas, what does it mean to view these images, what does it tell us about the viewer, the inherent fascination, the repetition of themes and the legacy that fails to offer either warning or education.

The issue of use of imagery in dark subject area interpretation such as execution sites, mass graves and concentration camps presents similar issues. Orthodox museum display condones the feeling that one can stand back from the past and be 'educated' about it. Even relatively innovative museums, such as the US Holocaust Memorial Museum, Washington DC, promote the idea of the past as 'another country' (Walsh, 1992). In such a context images are used to convey a perspective of the past as a place which is separate from the present, and which one travels to and visits via a combination of recreation and authentic elements. In contrast, the sites themselves represent reality and here the task of the interpreter is vitally important in terms of allowing the public to differentiate between truth and falsity, replication and reality.

Yet interpretation and how images are used can convey themes of dominant ideology as could be seen in the interpretation of concentration camps in the former Communist states in Central/Eastern Europe. In many of these countries, the Second World War was used as an ideological vehicle to expose the evil consequences of Fascism and Western capitalist exploitation and to commemorate and celebrate Russia and Soviet Communism as the force of liberation. This type of 'political' interpretation is still evidenced in some locations wherein narratives are from a victors' or victims' perspective. History is abridged and offered in episodic elements to enable the viewer to digest complex histories within a busy travel itinerary. Thus the danger of distortion or dilution is ever present. In some of the locations Tézenas has chosen to photograph – Rwanda, Lebanon and Cambodia – Western viewers' perceptions of histories are often at best partial. Detailed historical analysis is absent from guidebooks or online sources, thus, for many, the site itself becomes the historical record. The problems of interpretation are akin to the problems faced by the photographer. They are related to the difficulties of representation (creating a truthful account of the reality of such places) and presentation (paying tribute to and understanding the predicament of the victims and the context of the tragic history). The dilemma of avoidance of ideological distortions or deceptions is passed to the viewer. It becomes beholden on those individuals to research, or not, and to attempt to understand what they are seeing or simply view in a passive sense. Thus, whether we view a deserted playground in the Ukraine or an earthquake ruins tour in Sichuan, the photographer offers us a perspective that is multifaceted in composition, intent and meaning.

The alternative is to simply ignore this element of human fascination. In essence, that would be to leave these dark sites without interpretation and simply not to develop them. Literally to adopt the call for silence made earlier by Wiesel (1960) who claimed that: "Auschwitz negates any form of literature, as it defines all systems, all doctrines" (op. cit. p.7).

Steiner went further, arguing that it is best: "…not to add the trivia of literary, sociological debate to the unspeakable" (Steiner, 1967 p.163). However, to remain silent and not to record and interpret this content brings with it problems of displacement that may encourage future generations to ignore or forget the incidence of these tragic events or these terrible periods of human history. As Donat tells the listener in the name of Ignacy Schipper (the Warsaw historian): "… everything depends on who transmits our testament to future generations, on who writes the history of this period.

History is usually written by the victor ... should our murderers be victorious, should they write the history of this war, our destruction will be presented as one of the most beautiful pages of world history, and future generations will pay tribute to them as dauntless crusaders. Their every word will be taken for gospel. Or they may wipe out our memory altogether as if we had never existed, as if there had never been a Polish Jewry, a Ghetto in Warsaw, a Maidanek. Not even a dog will howl for us." (Donat, 1995, p6)

This work in this book is masterly, technically assured, probing, ironic, synonymous with our past and present. These images are about much more than tourism and the visiting of such sites, they challenge the nature of our behaviour, our history and our societies' relationship with evil and mortality. They are a testament to our past, to our inability to move beyond it and our curious relationship with tragedy and death.

Barthes, R. (1981) *Camera Lucida: Reflections on Photography,* Trans. R. Howard, New York, Hill and Wang.

Donat, A (1965) *The New Kingdom*, New York, Holt Reinhart and Winston.

Lanzmann, C. (1995) 'Why Spielberg has Distorted the Truth' in *The Guardian Weekly* 3 March p.18.

Lanzmann, C. (1995) quoted in I Avisar (1988) *Screening the Holocaust*, Bloomington and Indianapolis, Indiana University Press.

Lennon, J.J. (1996) 'JFK and Dark Tourism: A Fascination with Assassination' in the *International Journal of Heritage Studies Vol. 2, No 1* (pp 198-211) with Foley, M.

Lennon, J.J. and Foley, M. (2000) *Dark Tourism – the Attraction of Death and Disaster*, Continuum.

Lennon J and Mitchell M (2007) 'Dark Tourism the Role of Sites of Death in Tourism' in Mitchell M (Editor) (2007) *Remember Me Constructing Immortality – Beliefs on Immortality, Life and Death*, Oxford, Routledge.

Lennon J (2010) 'Dark Tourism and Sites of Crime' in Botterill D and Jones T (Eds) (2010) *Tourism and Crime*, Oxford, Goodfellow Publishers.

Lennon J Wei D Litteljohn D (2012) 'Dark Tourism: The case of the memorial to the victims of Nanjing (Nanking) Massacre, China' in White and Frew E (2012) *Dark Tourism and Place Identity: Marketing, Managing and interpreting dark places*, Oxford, Routledge.

Lennon J (2009) 'Tragedy and Heritage in Peril: The Case of Cambodia' in *Tourism Recreational Research* (Vol 3 No 2 pp 116-123).

Levi, P (1990) *The drowned and the saved*, Abacus.

Levi, P (1986) 'Revisiting the Camps' in Young, J E (ed) *The Art of Memory: Holocaust Memorial in History*, Prestel.

Romney, J. (1995) 'Screen Seen: Vital Video – The Holocaust' in *The Guardian Weekly* 13 January p.T016.

Steiner, G. (1967) *Language and Silence: Essays in Language, Literature and the Inhuman*, New York: Athenaeum.

Steiner, G. (1971) *In Bluebeard's Castle: Some Notes Towards the Redefinition of Culture*, New Haven, Yale University Press.

Walsh, S. (1992) *The Representation of the Past*, Oxford, Routledge.

Wiesel, E. (1960) *Night translated*, S. Rodway, New York, Avon.

Wiesel, E. (1968) *Legends of our Fire*, translated by S. Donadio, New York, Holt, Reinhart and Winston.

Oradour-sur-Glane, martyr village - France

The total annihilation of the village of Oradour-sur-Glane and its people, and the ruthless determination of the executioners, has, since 1944, raised Oradour to the ranks of 'the archetype of the massacre of civilian populations'. On 28th November 1944, the provisional French Government took the decision to classify and preserve the ruins, drawing national recognition to Oradour. These measures saw the martyr village become the symbol of a France wounded by the German occupation. During his visit in March 1945, General De Gaulle recalled "that a place like this remains as something common to us all, something through which everyone can recognise a shared misfortune, a shared will and a shared hope."

(Source: Centre of Memory, Oradour-sur-Glane, France)

The martyr village of Oradour-sur-Glane,
main electric tramway line

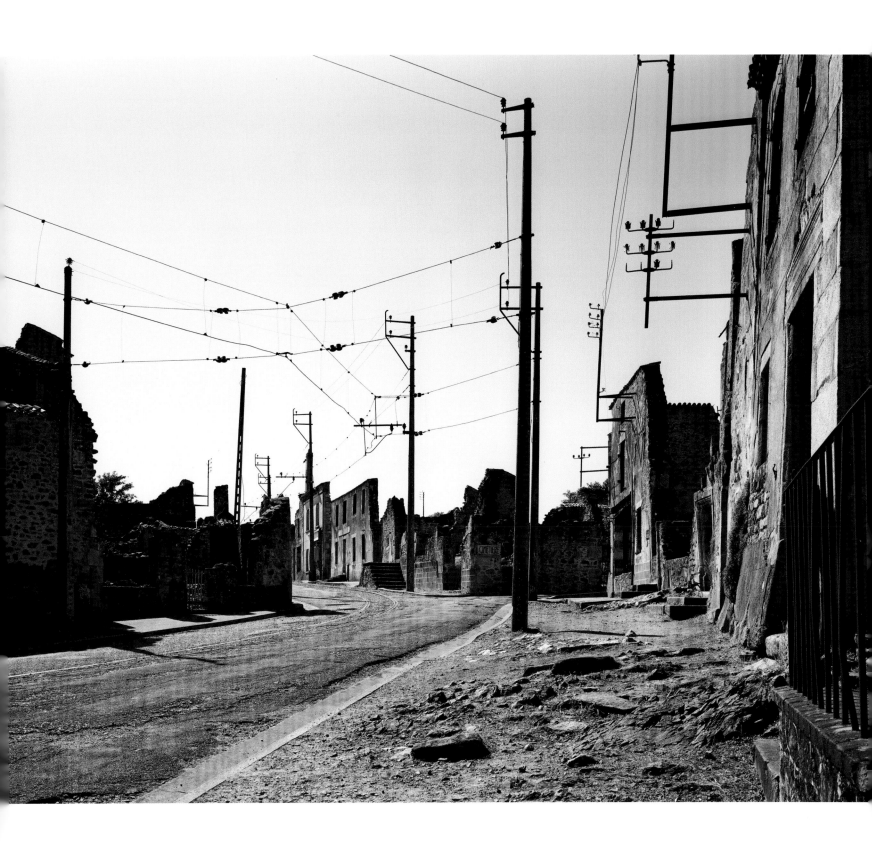

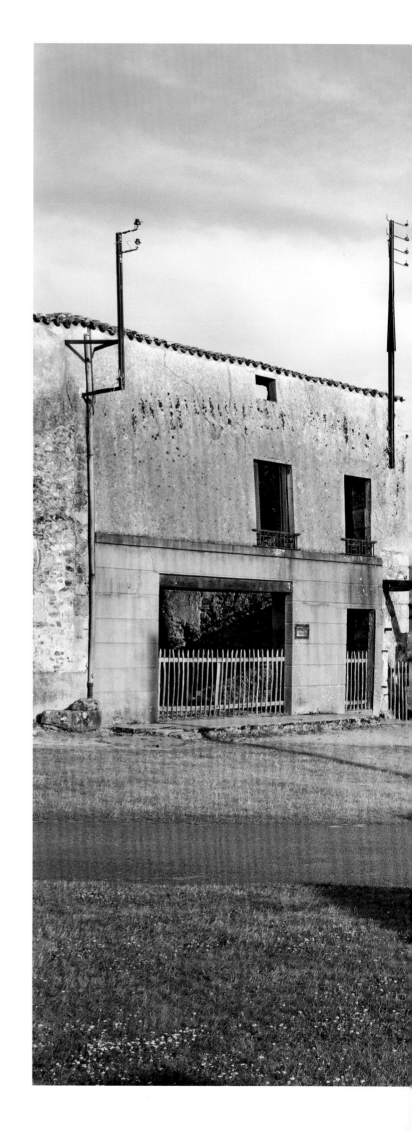

The martyr village of Oradour-sur-Glane,
Fairground

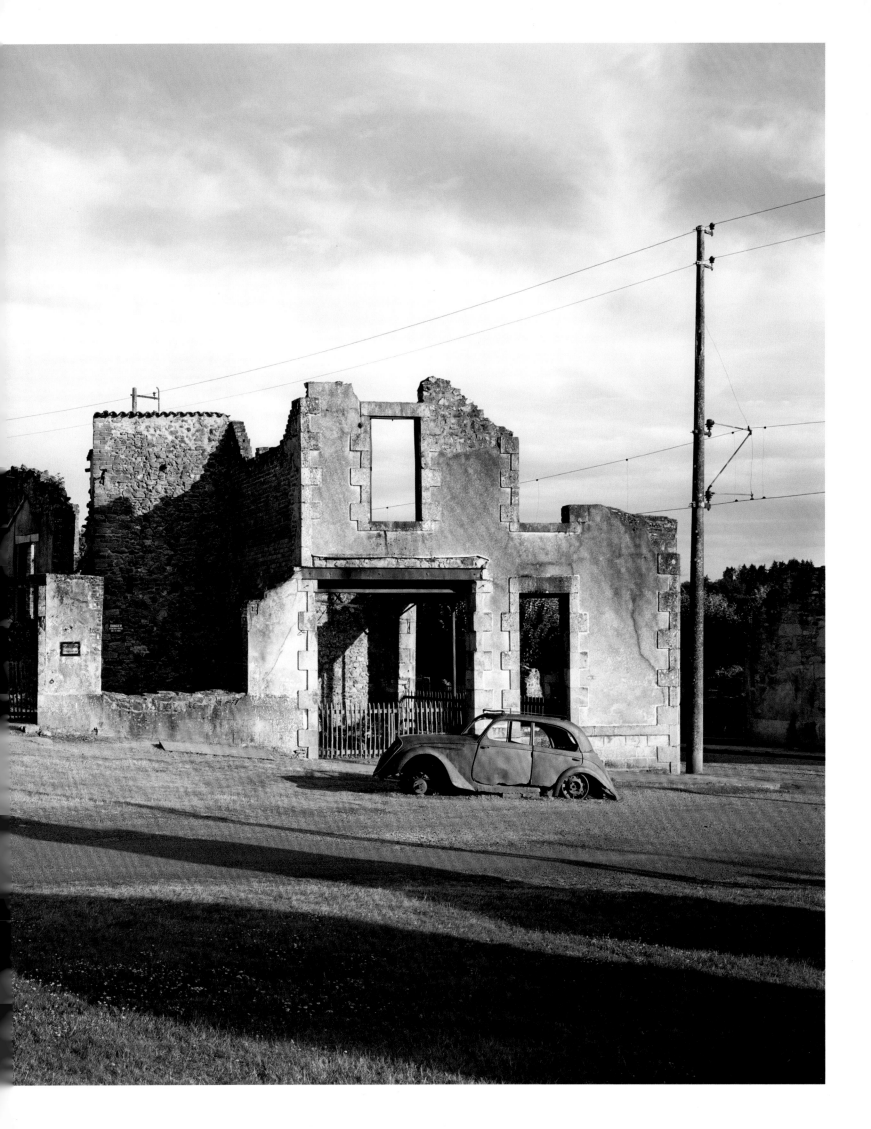

The martyr village of Oradour-sur-Glane, main street

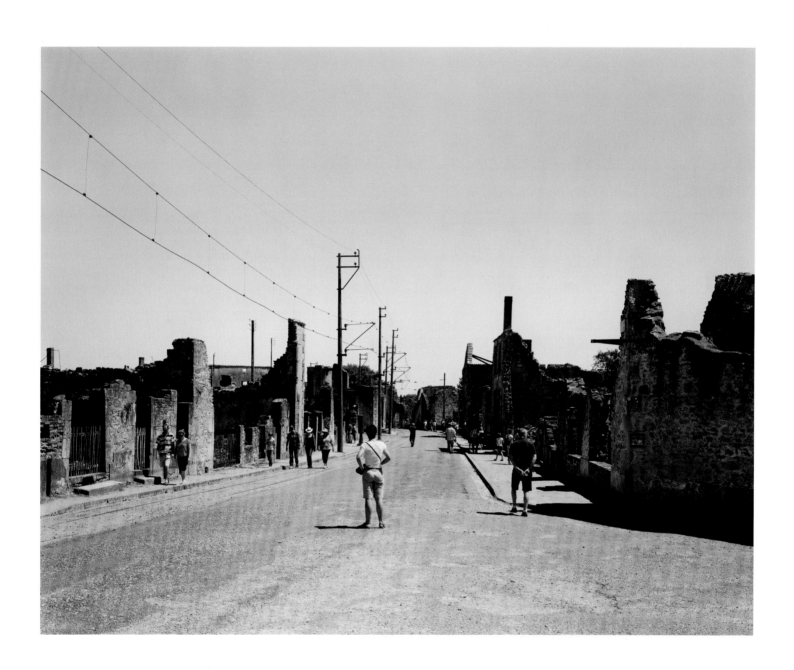

The martyr village of Oradour-sur-Glane, bell tower execution site

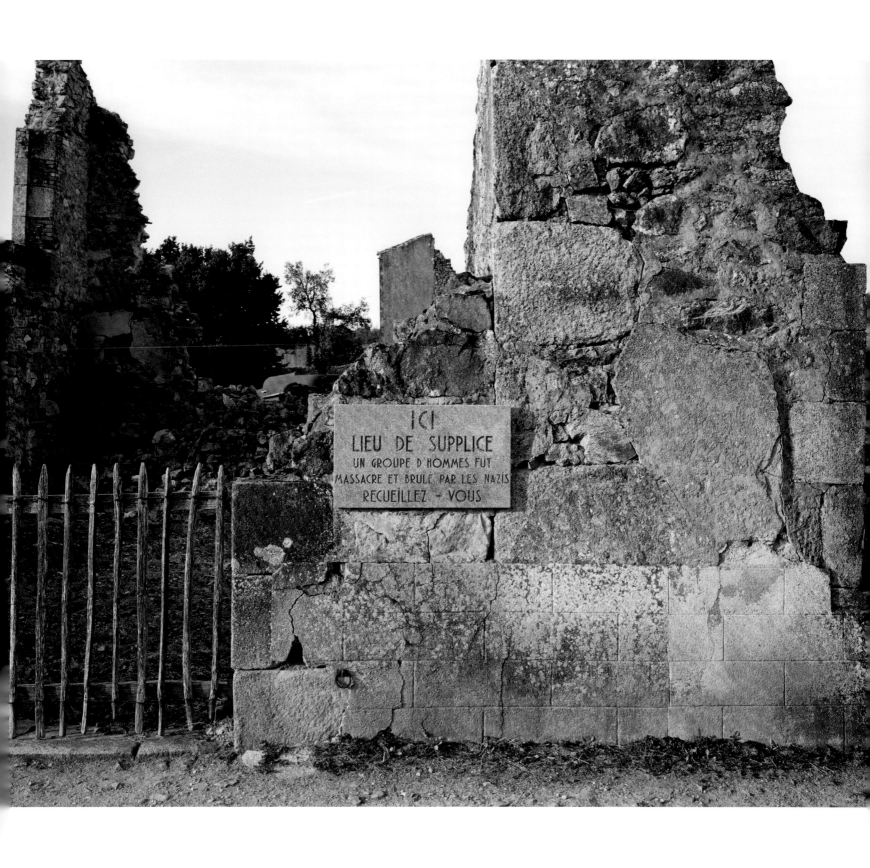

The martyr village of Oradour-sur-Glane, Lanot butcher's shop

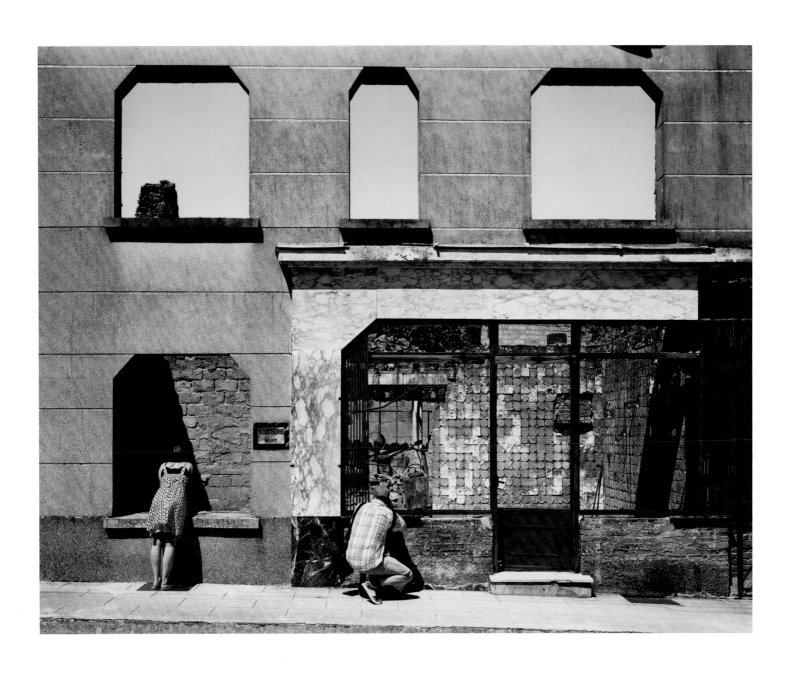

The martyr village of Oradour-sur-Glane, fairground

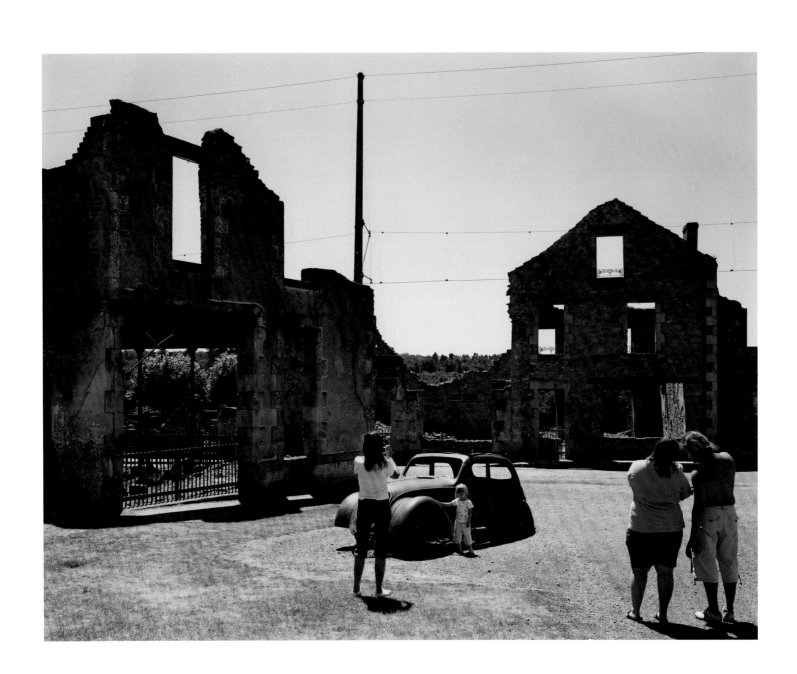

The martyr village of Oradour-sur-Glane

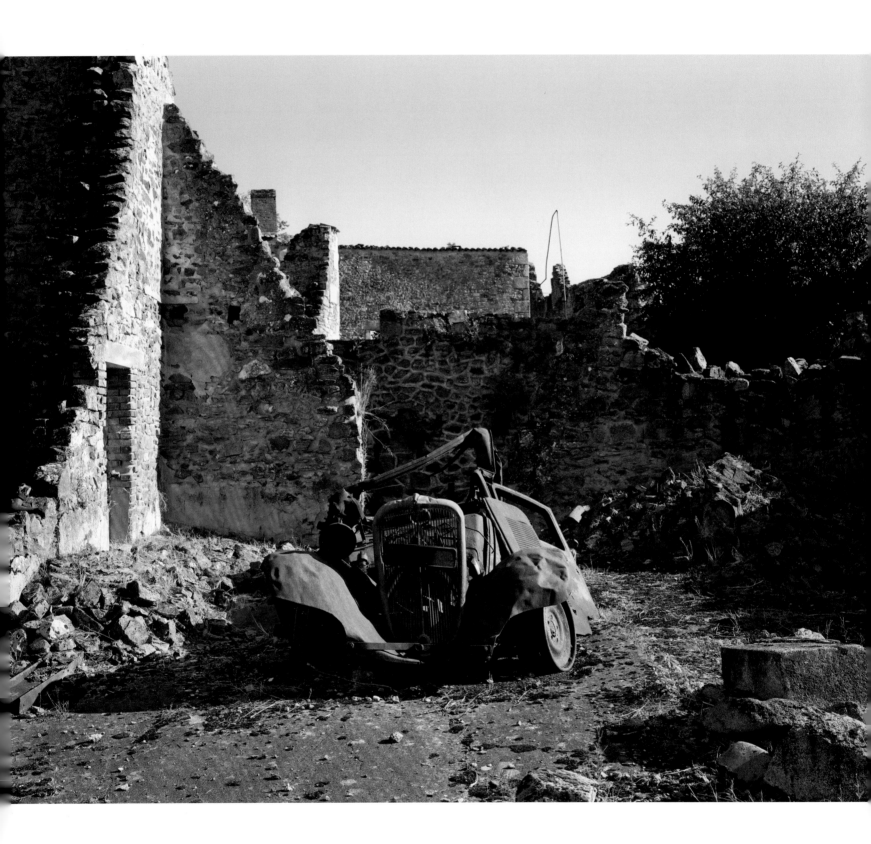

The JFK Assassination Trail – USA

A journey to November 22, 1963:
Revisiting the Scenes of an Extraordinary Story

A tour for groups that delves into one of the most intriguing mysteries of our time: the history-changing assassination of President John F. Kennedy. This tour can be as short as half a day or as long as a full nine-to-six day. It can include lunch in the West End in Dallas near the Sixth Floor Depository Museum. This excursion appeals to anyone who has even a passing interest in one of the Twentieth Century's most noteworthy tragedies. Most people are familiar with the Sixth Floor Museum, the site from which Lee Harvey Oswald allegedly fired the deadly shots, but there are many other places around Dallas associated with the assassination that are just as important. Most of these are completely unknown to the casual observer and are unmarked as to their role in the event, but they are vitally important to understanding what happened that day.

(Source: Heritage Tour, Dallas)

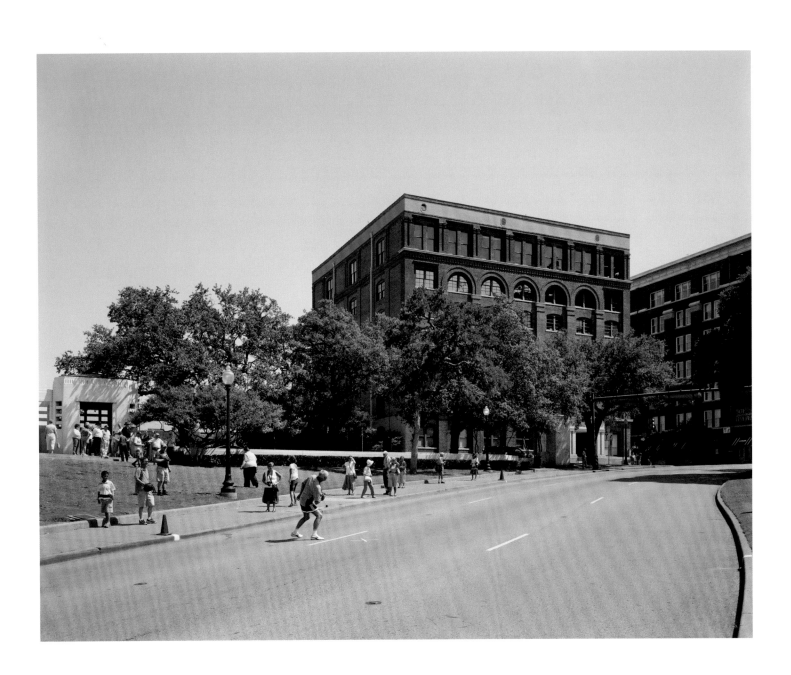

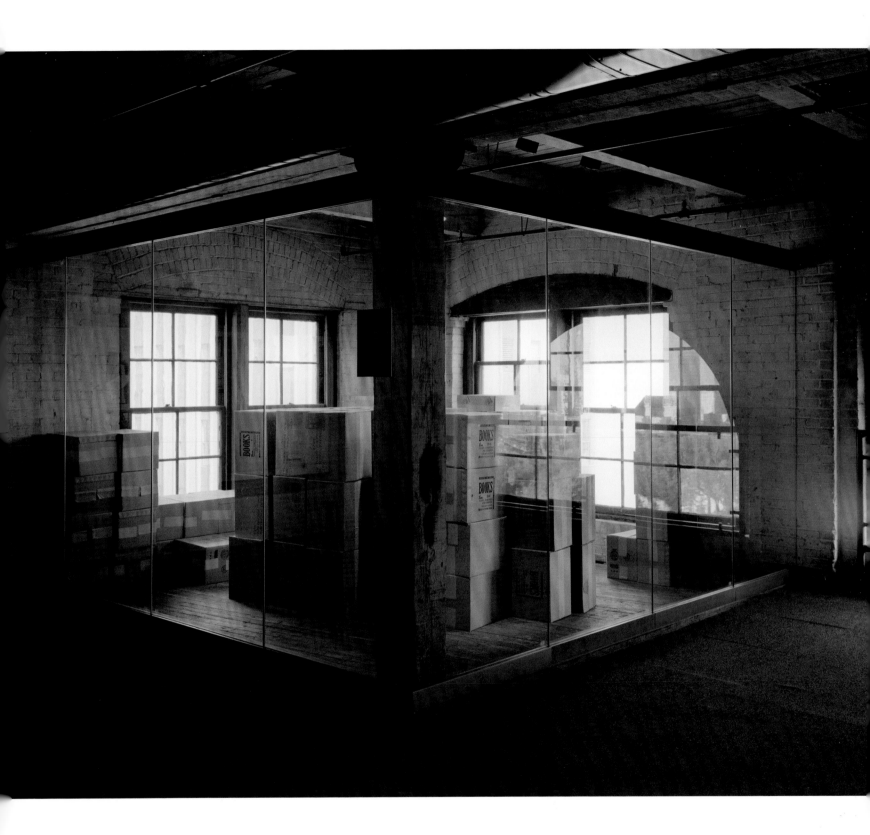

The JFK Assassination Trail
The Oak Cliff rooming house where Oswald was living in November, 1963,
after a series of address moves and a mysterious trip to Mexico that Fall

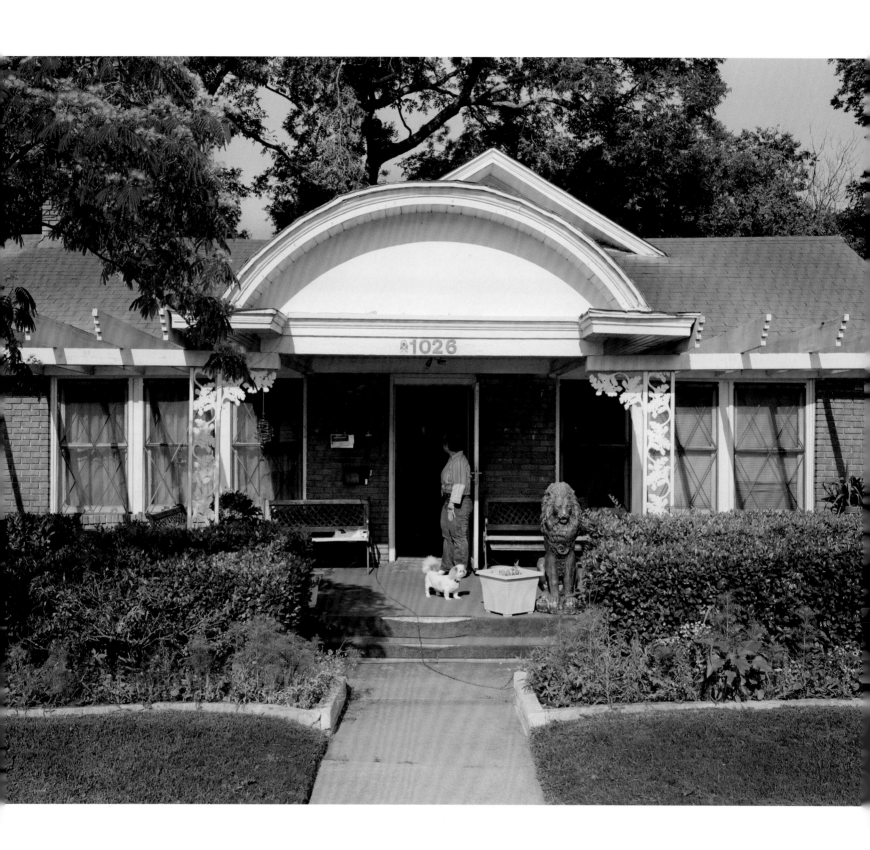

The JFK Assassination Trail
The basement tunnel at the Dallas Municipal Courts Building
where Jack Ruby killed Oswald on live national television

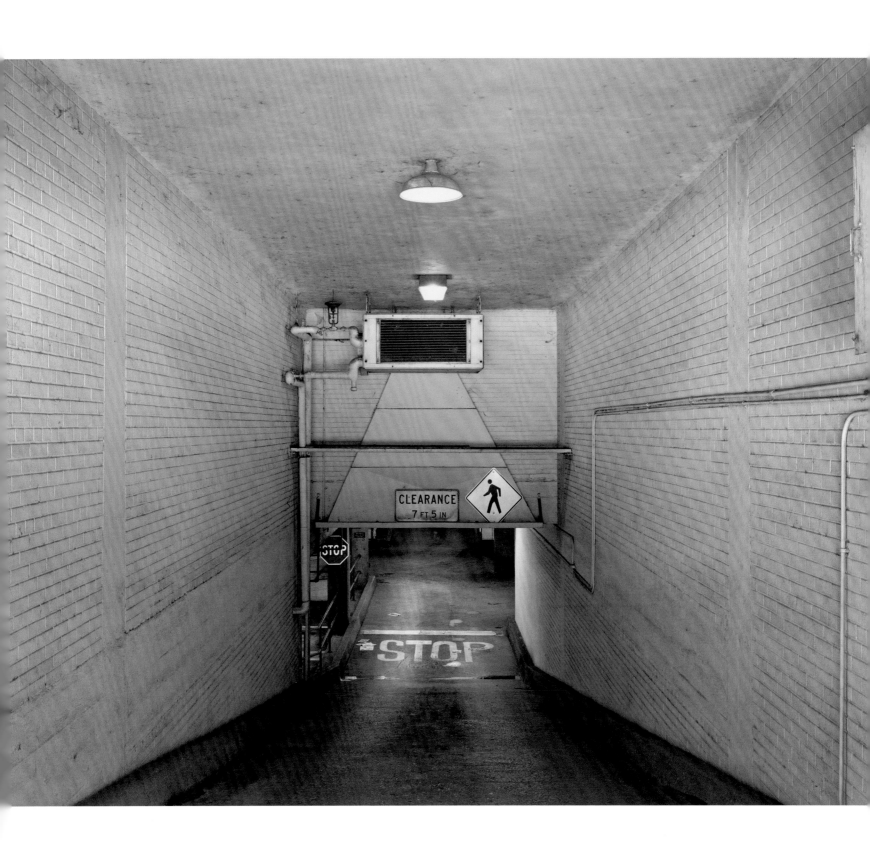

The JFK Assassination Trail
Former Oswald residence in the Oak Cliff area of Dallas
prior to the Assassination

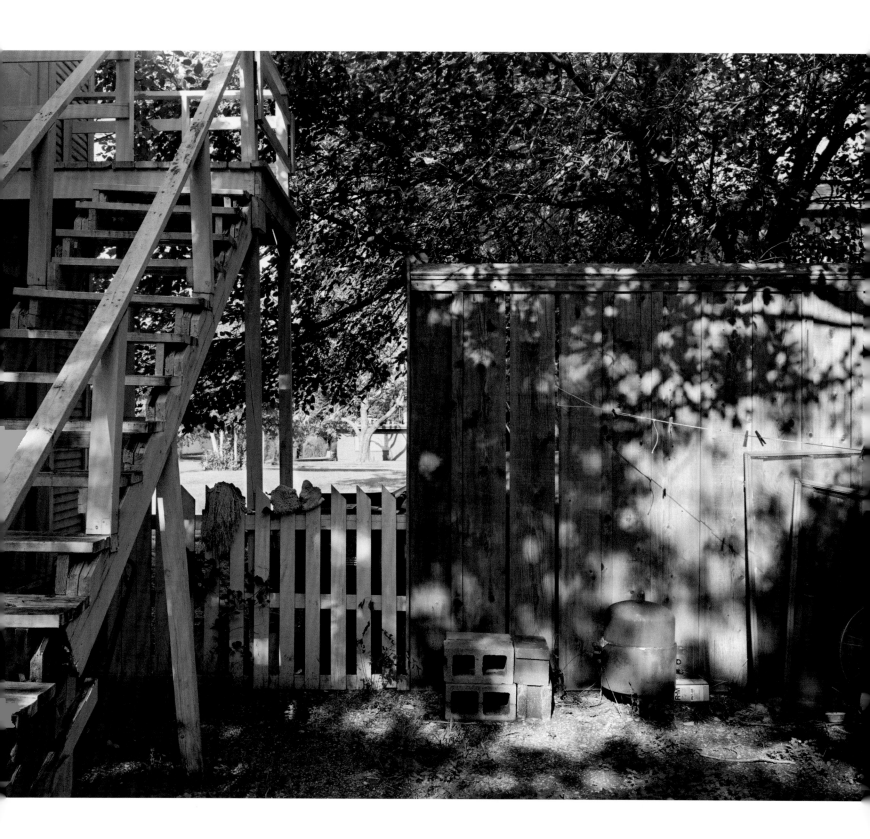

The JFK Assassination Trail
The Texas Movie Theater a few blocks away where
Oswald fought with police and was captured

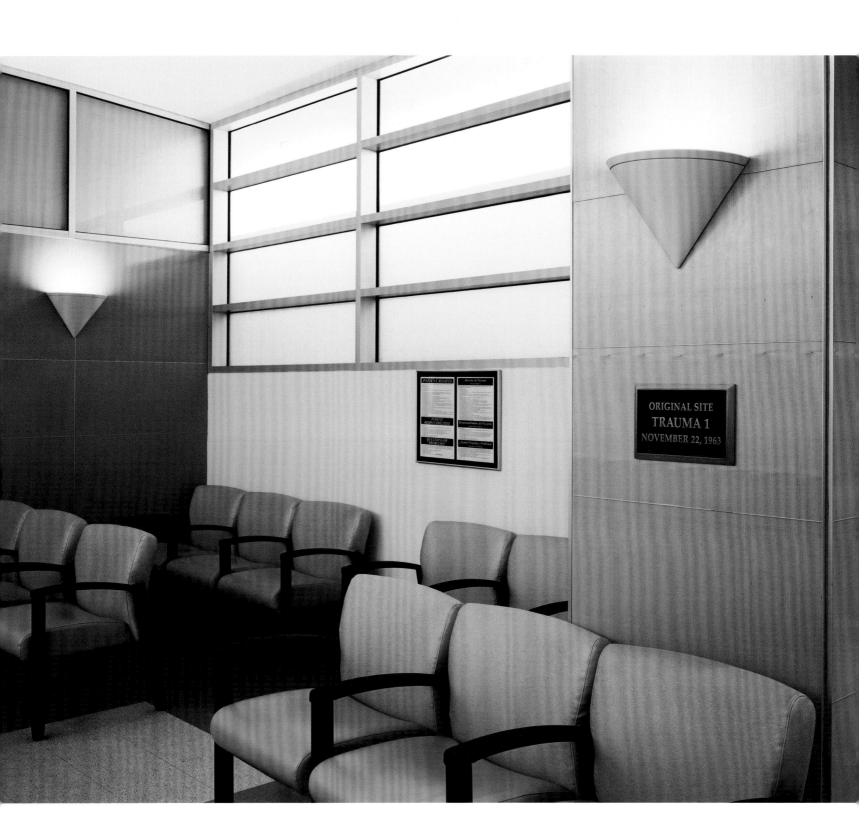

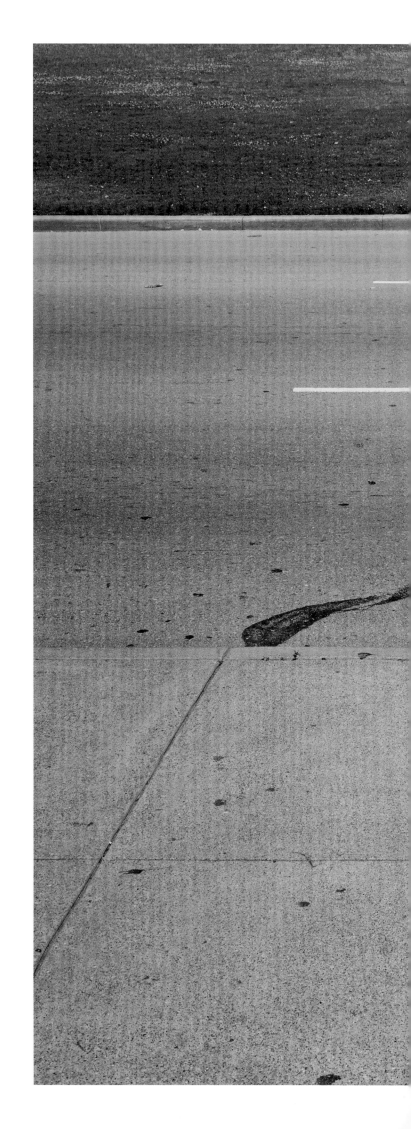

The JFK Assassination Trail
The grounds of Dealey Plaza

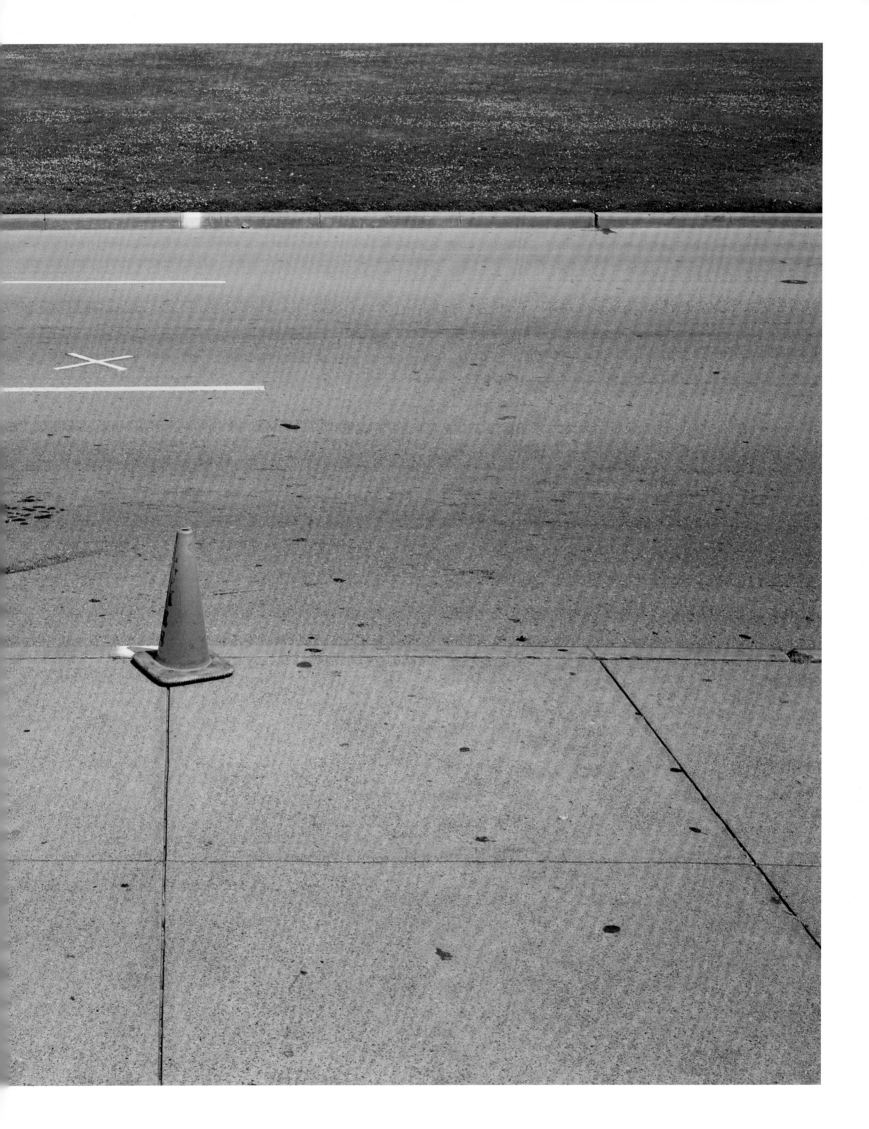

The grave of Lee Harvey Oswald on the outskirts of Fort Worth,
a spot with its own mysteries and curiosities

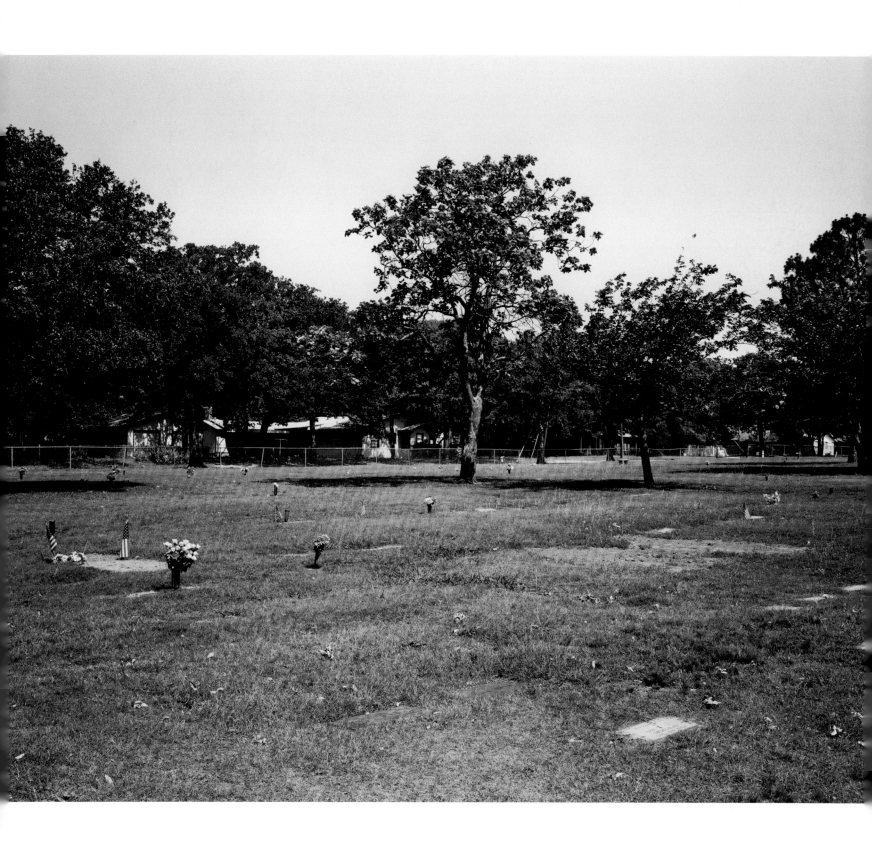

Tuol Sleng Genocide Museum – Cambodia

The Khmer rouge clique led by Saloth Sar created a secret 'prison' in order to detain, interrogate, torture and finally execute prisoners when they had been processed. The prison was entitled Security 21 'S.21' and directed by Kaing Kek Iev (Duch), a former schoolteacher in Kampong Thom Province. On January 7, 1979 the Party and the Government collected all the evidence in S-21 such as photographs, films, the prisoner confession archives, torture tools, shackles, and the fourteen victims corpses (one of them was female). Now the evidence of the criminal regime is at display for Cambodian and international visitors. Making the crimes of the inhuman regime of Khmer Rouge public plays a crucial role in preventing a new Pol Pot from emerging in the lands of Angkor or anywhere in the world.

(Source: Tuol Sleng Genocide Museum, Phnom Penh)

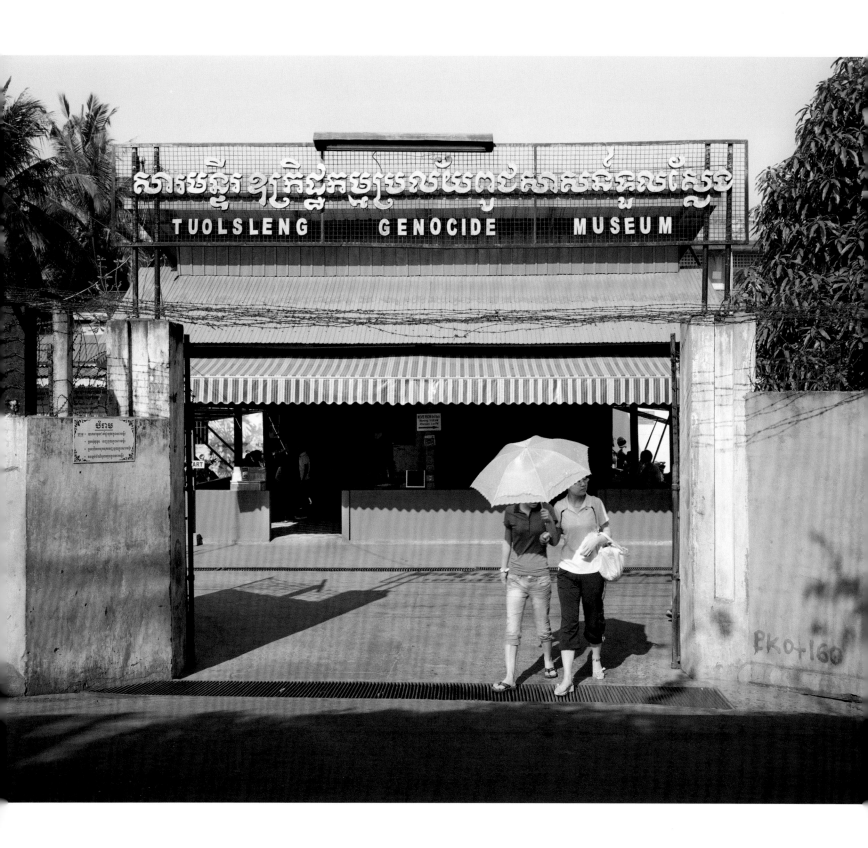

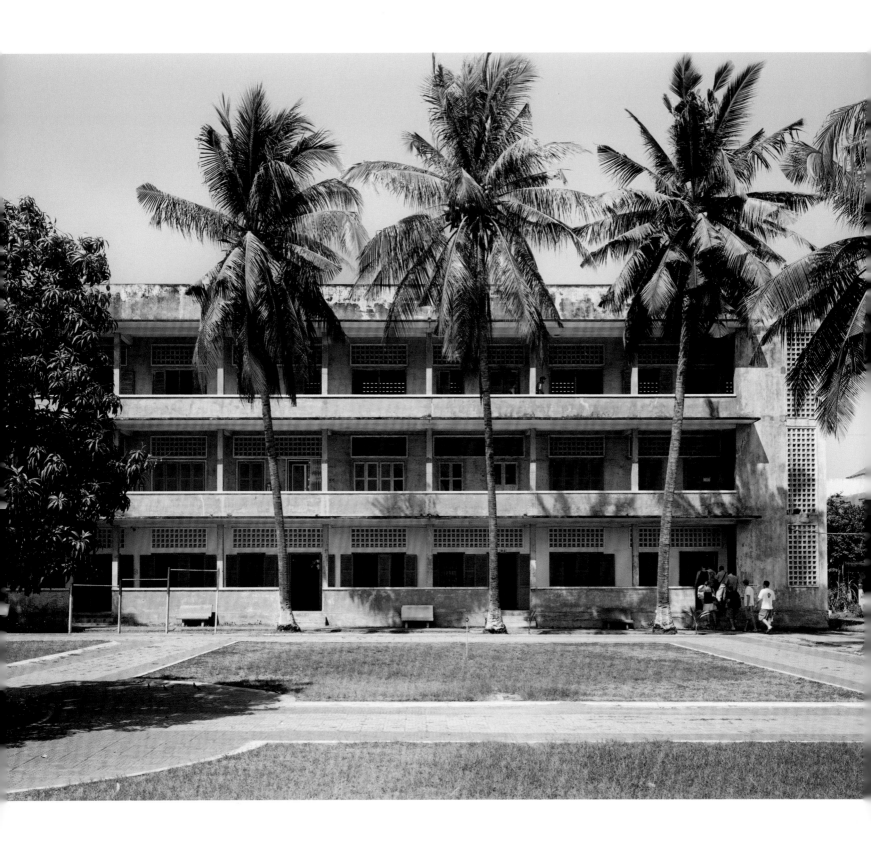

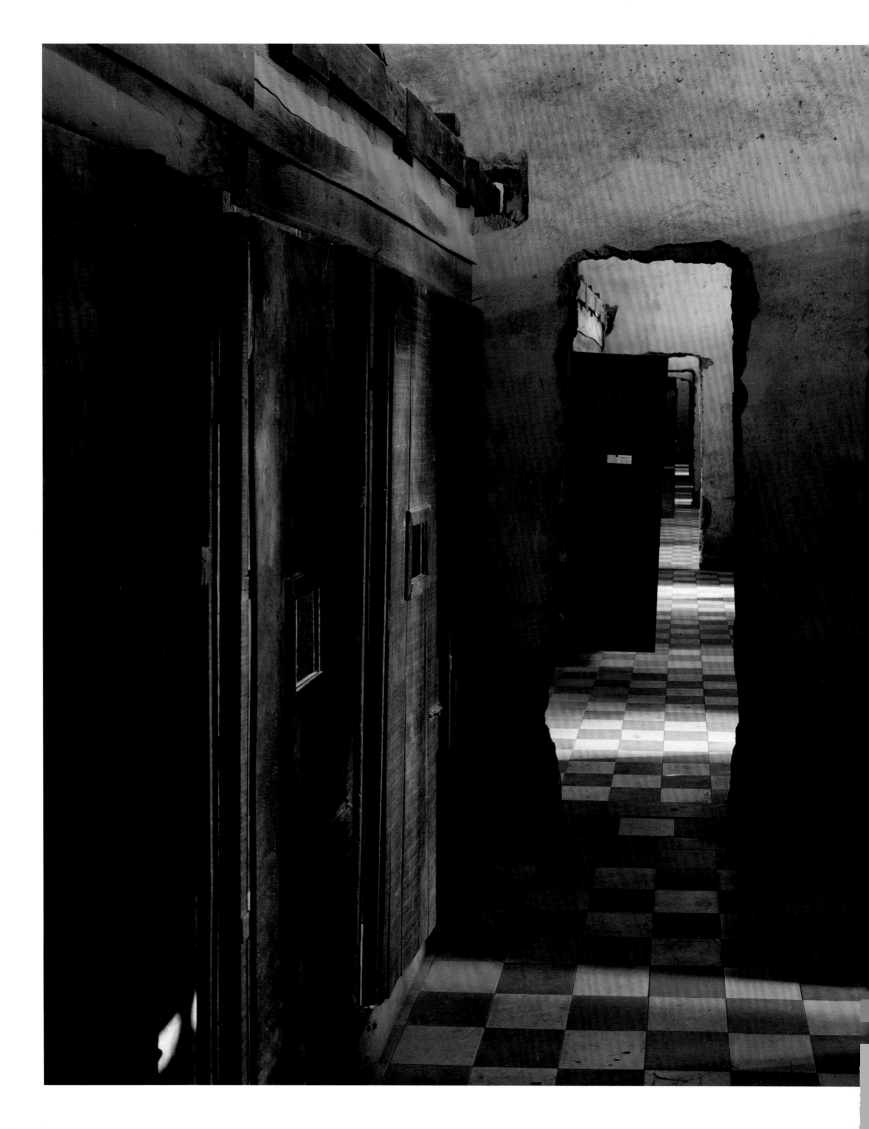

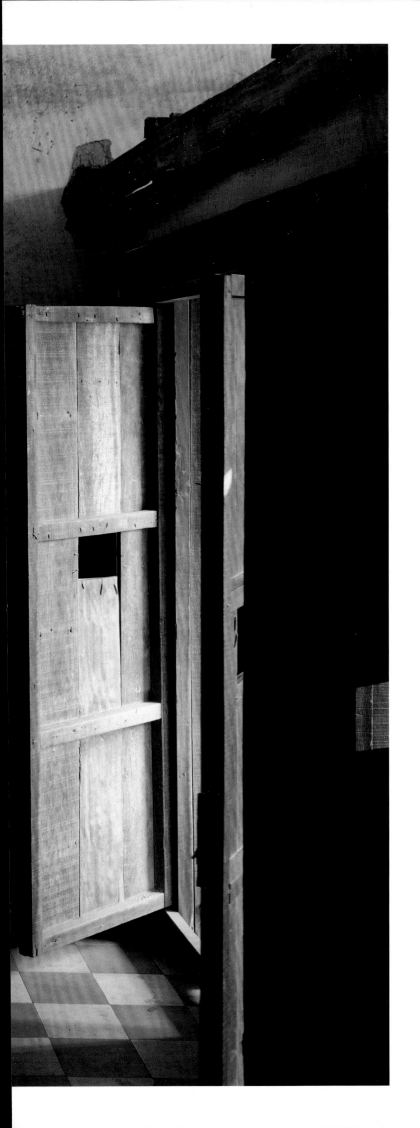

Tuol Sleng Genocide Museum
The ground floor had been divided by
clumsily bricked partitions into small cells
of .80m x 2.00m where each prisoner was caged

In 1977-1978 Building 'A' was converted into a set of rooms 6 x 4 meters each, the window were paneled with glass to minimize the sound of prisoners' screams heard outside the facility in times of torture. Building "A" was used for detaining cadres who were accused of leading the uprising against Pol Pot revolution

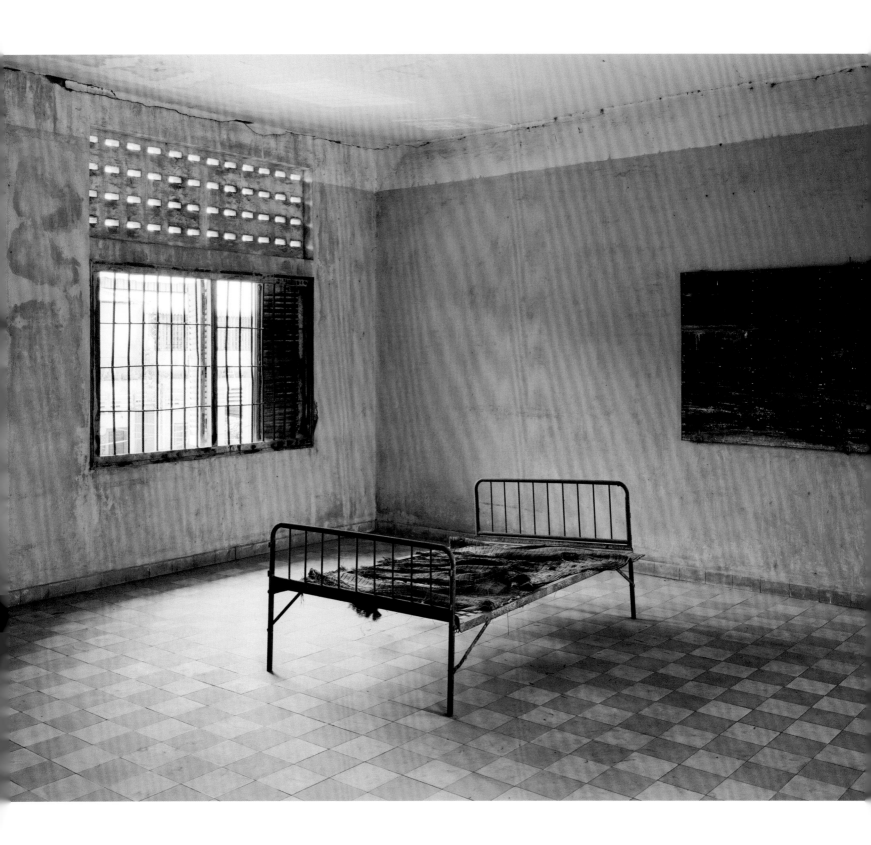

Choeunk Ek memorial (The Killing Fields)
Killing tree against which executioners beat children

Choeunk Ek memorial (The Killing Fields)

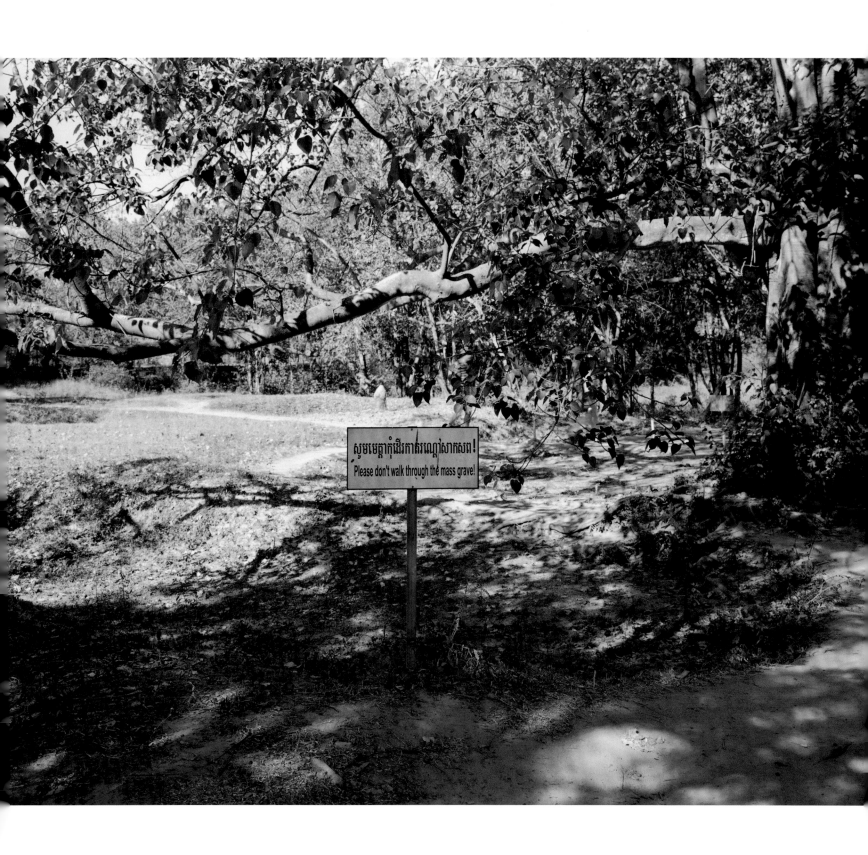

Tuol Sleng Genocide Museum

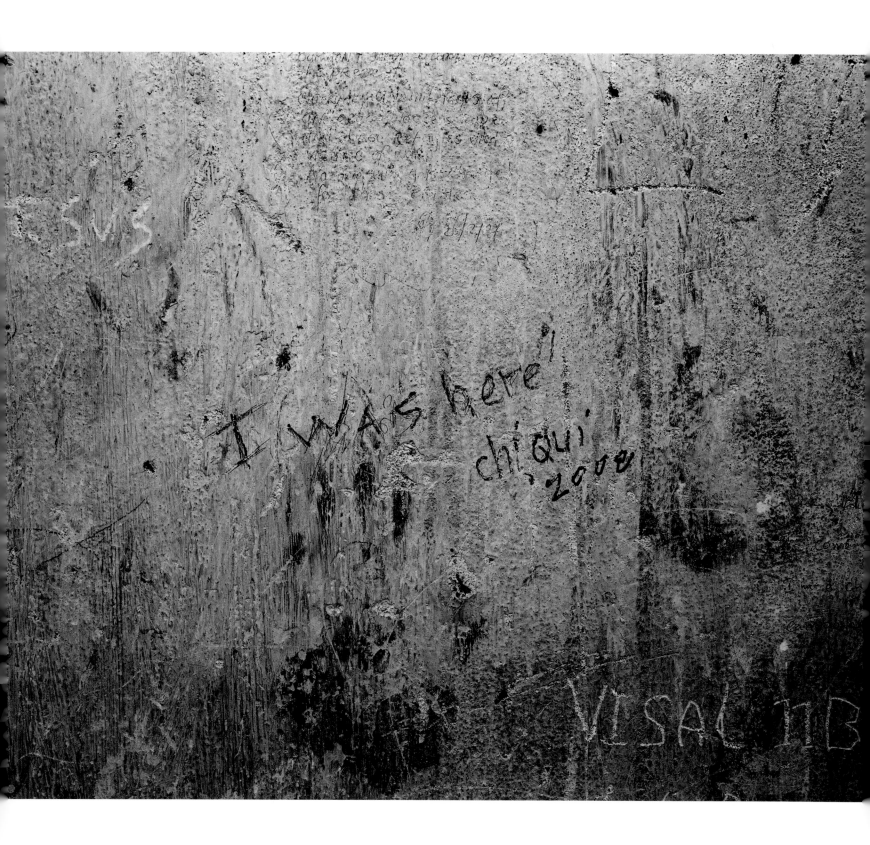

Choeunk Ek memorial (The Killing Fields)

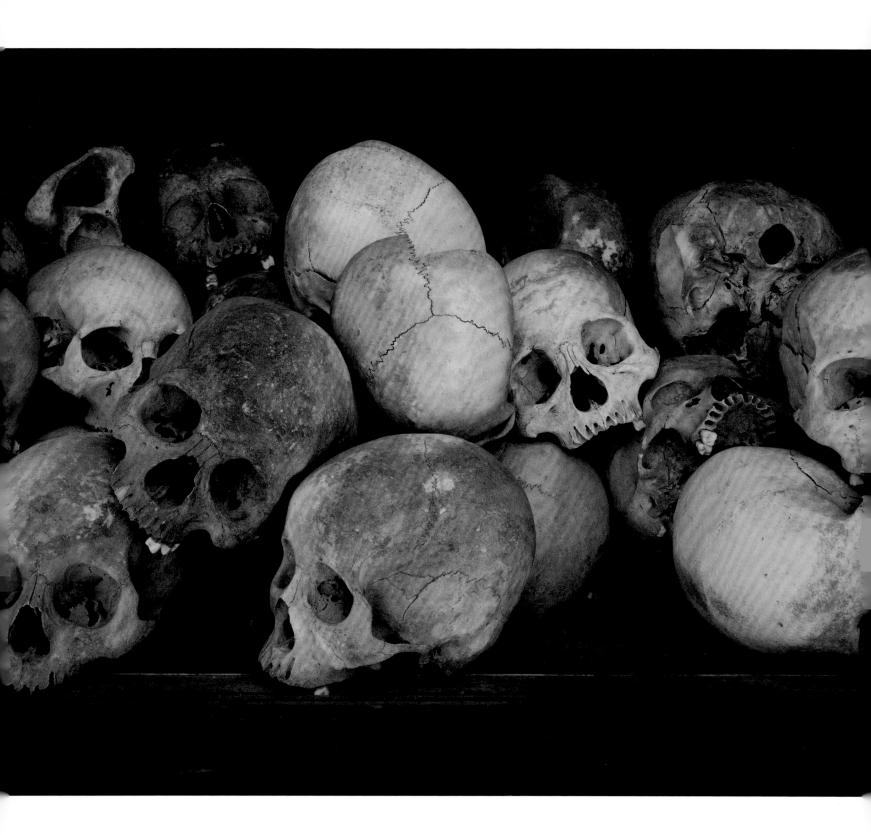

Choeunk Ek memorial (The Killing Fields)
Choeunk Ek souvenir shop

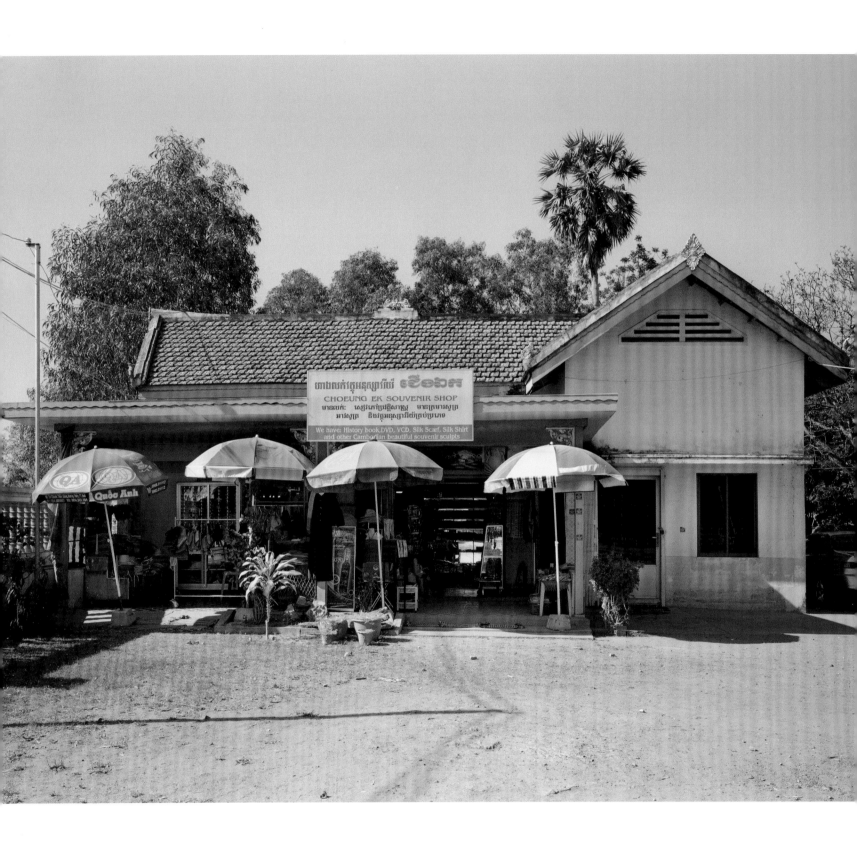

Gruto Parkas – Lithuania

The Grutas Park exposition discloses the negative content of the Soviet ideology and its impact on the value system. The aim of this exposition is to provide an opportunity for Lithuanian people, visitors coming to our country as well as future generations to see the naked Soviet ideology which suppressed and hurt the spirit of our nation for many decades. To date, no other museum or cultural institution has endeavoured to collect or duly exhibit Soviet relics. In Grutas Park, monumental sculptures are positioned in a 2 km-long exposition, where guard towers, fragments of concentration camps and other details resemble Siberia. Grutas Park is situated on a 20 hectare site, exhibiting 86 works by 46 authors. Such a large concentration of monuments and sculptures of ideological content in a single out-door exposition is a rare and maybe even unique phenomenon in the world.

(Source: Gruto Parkas, Lithuania)

Gruto Parkas
'V.I.Lenin' by sculptor N.Tomskis
This statue stood in Lenin's Square, Vilnius, in 1952-1991

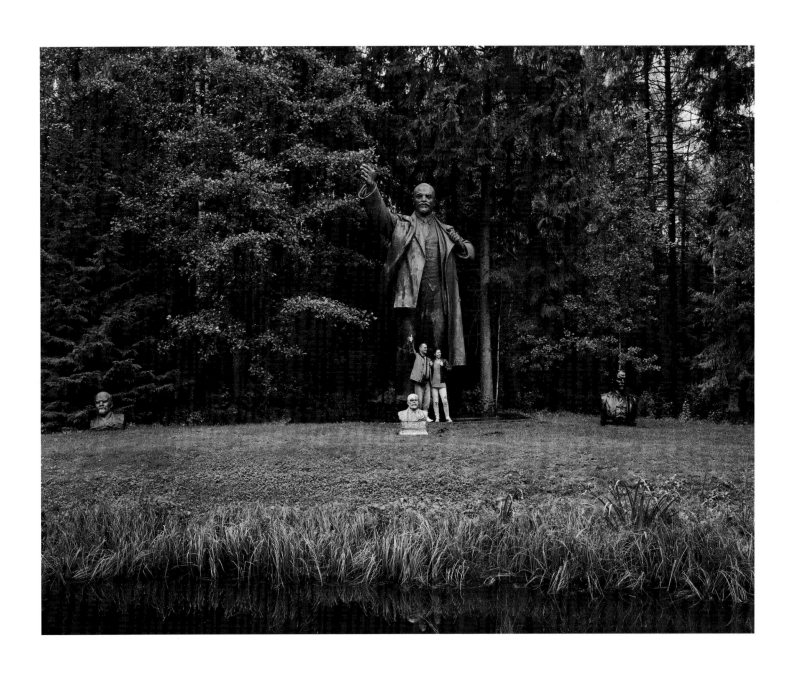

Gruto Parkas

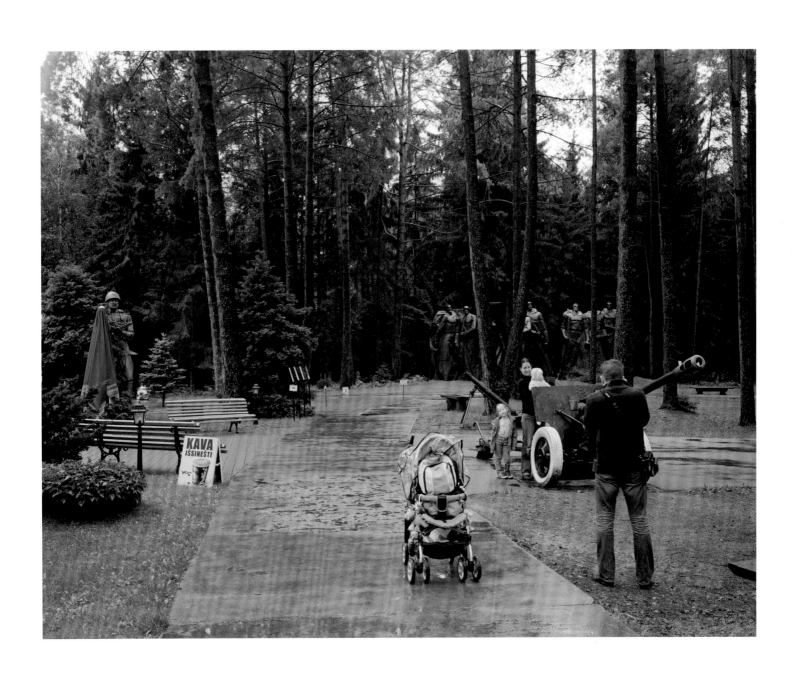

Gruto Parkas
'Tarybiniai partizanai pagrindinia'. Soviet sculpture exhibition

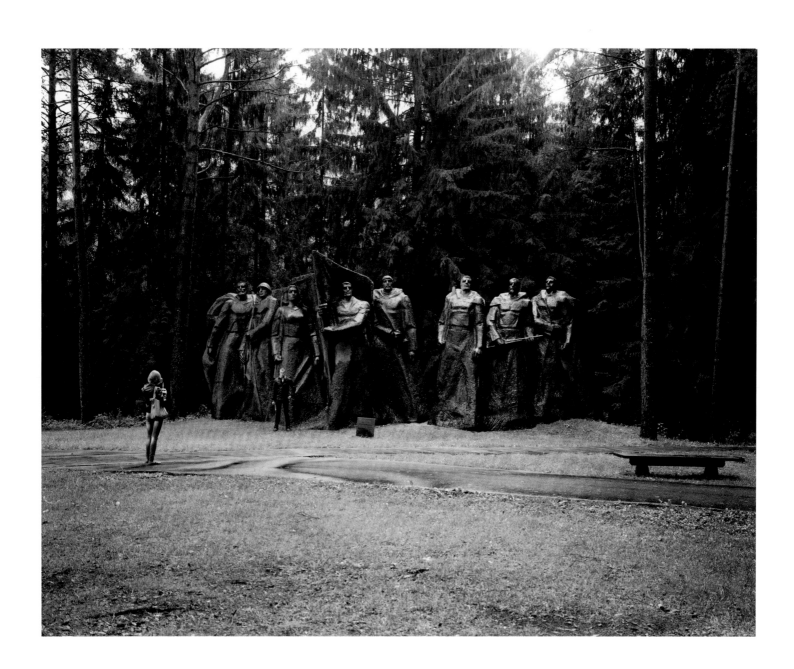

Gruto Parkas
F.Engelsas, K.Markas, V.Leninas, V.Mickevicius-Kapsukas, J.Stalinas

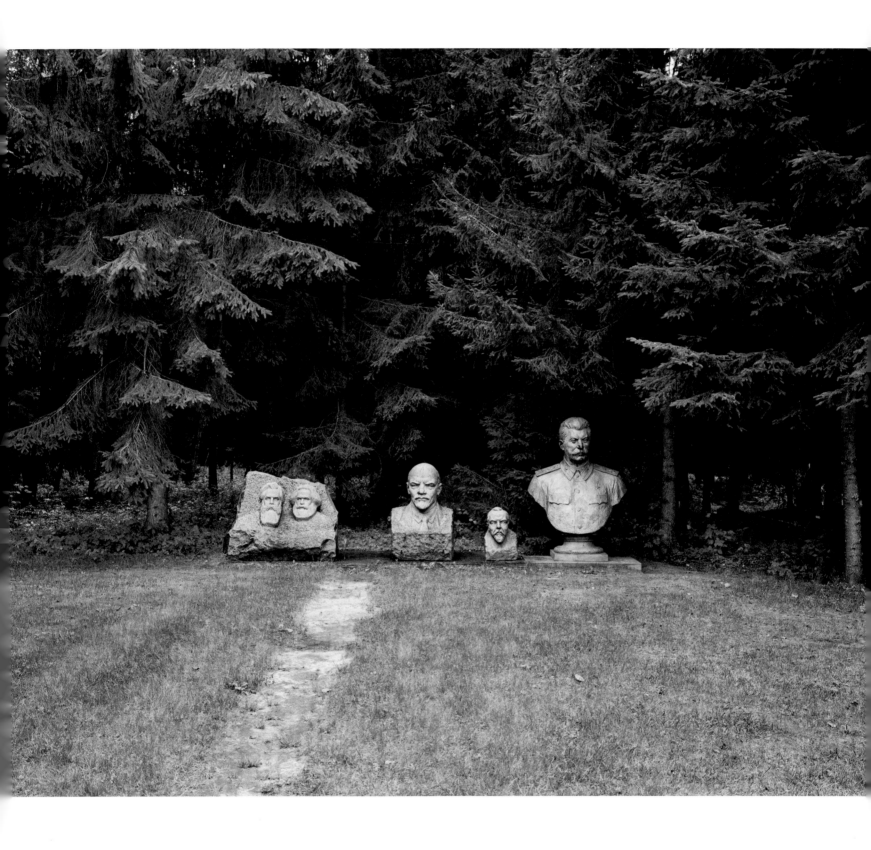

Gruto Parkas, Souvenir shop

Gruto Parkas

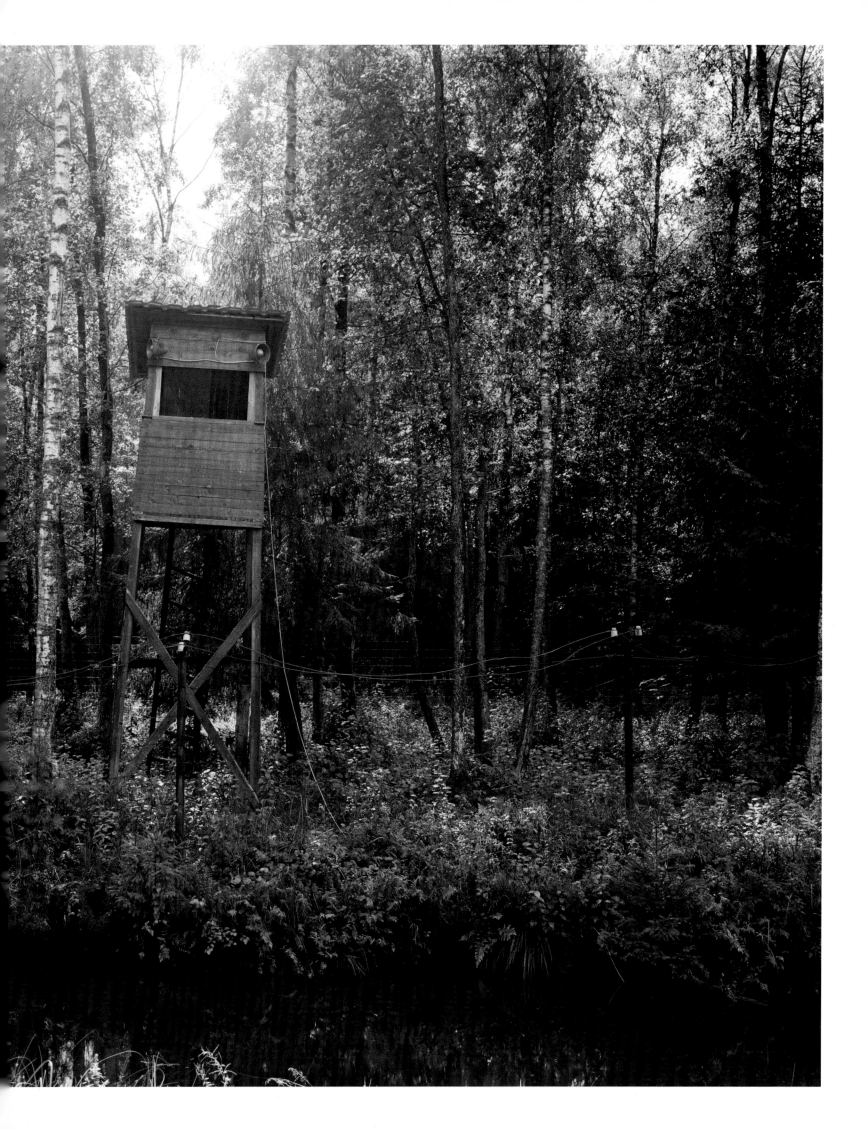

Gruto Parkas
Borshch 'Nostalgia' (Beetroot soup) 3,00 Lt

Gruto Parkas

The mass deportations had been executing with great secrecy lest people should not hide. Deportations were called by 'innocent' names 'Vesna' ('Spring'), 'Proboj' ('Braking the waves'), and 'Osen' ('Autumn'). But behind these 'innocent' names Lithuanians' families were robbed, they were put in to 'Zis'(a kind of lorry), loaded in to goods (cattle) vans and were taken to exile in Siberia. Let imagine the scale of horrors, then were taken of 18000, 30000, 40000 innocent people during 5-6 days crowded 'prisons on the wheels' without any sanitary or hygiene conditions. The travel lasted about a month.

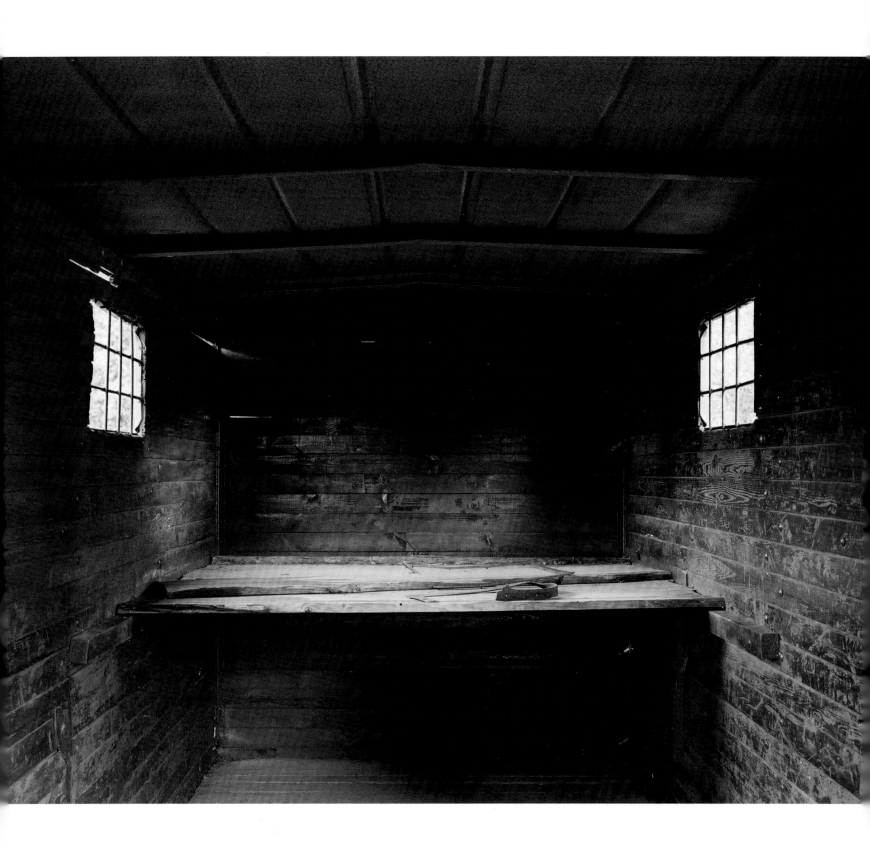

Karostas Cietums – Latvia

The prison started functioning over 100 years ago.
The only military prison in Europe open to tourists.
A prison nobody has escaped from.
Considered even more impressive than the Alcatraz in the USA.
More than 150 people have been shot here.

The building was erected about 1900 and operated until 1997. It served as a place where military persons served their terms for breach of discipline. From the very first years of its existence, it was a place to break people's lives and suppress their free will. As powers replaced one another, its prisoners changed as well: they included revolutionaries, seamen and non-commissioned officers of the tsarist army, deserters from the German Wehrmacht, enemies of the people in the Stalinist era, soldiers of both the Soviet army and the Latvian army and other rebels. The newest inscriptions on the cell walls by inmates date to fairly recently, 1997.

Behind Bars: The Show. A historical interactive reality show involving the audience. Created on the basis of true stories from life in the Naval Port prison. The purpose and essence of the show is to give each participant an opportunity to live the part of a prisoner and learn about the most interesting and shocking facts from the history of the prison. Only those over 12 years of age and brave enough are invited to participate. Participants will be asked to sign a statement agreeing to the conditions of the show. We therefore ask that you read the Agreement before applying.

Extreme night: Fans of especially extreme adventures are offered an overnight show. You will be able to step into the shoes of a prisoner on a dark and dismal night. Arrival at the Naval Port prison is at 9 p.m., and the show lasts till 9 a.m.

(Source: Karostas cietums, Latvia)

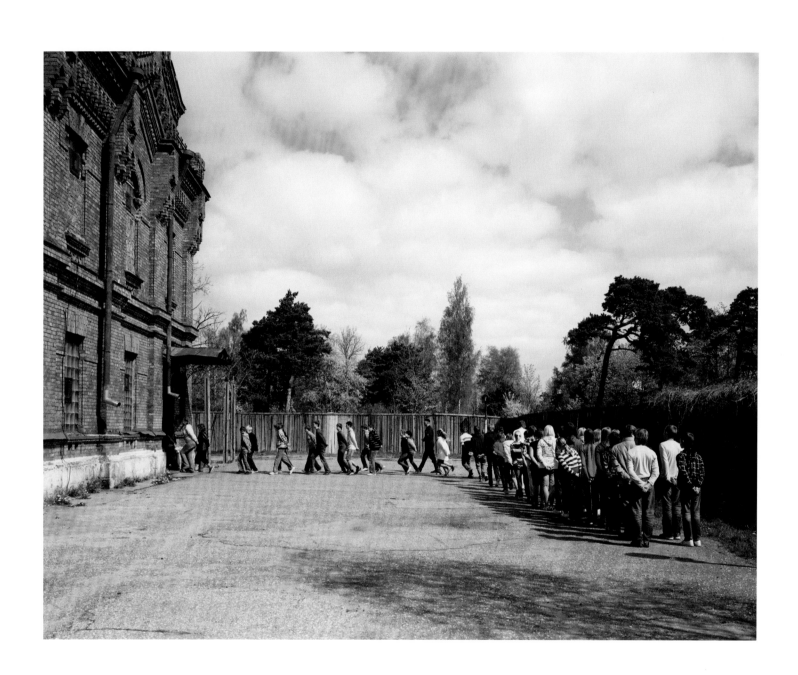

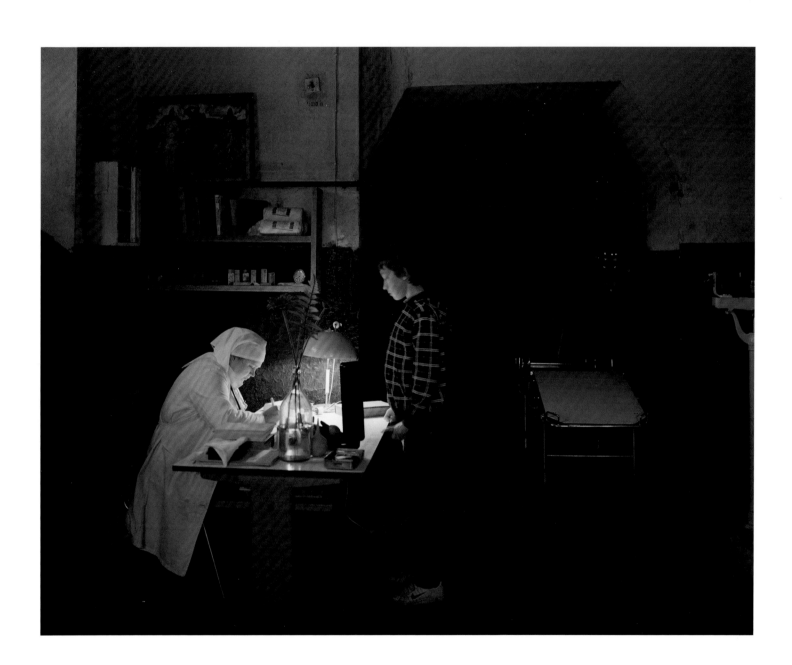

Who can you surprise by staying overnight at a hotel? Here you have a chance to spend the night in a prison which is considered to be even more impressive than the Alcatraz in the USA, to sleep on a prison bunk or an iron bed, and to have a prison meal. Price: Ls 8 per person.

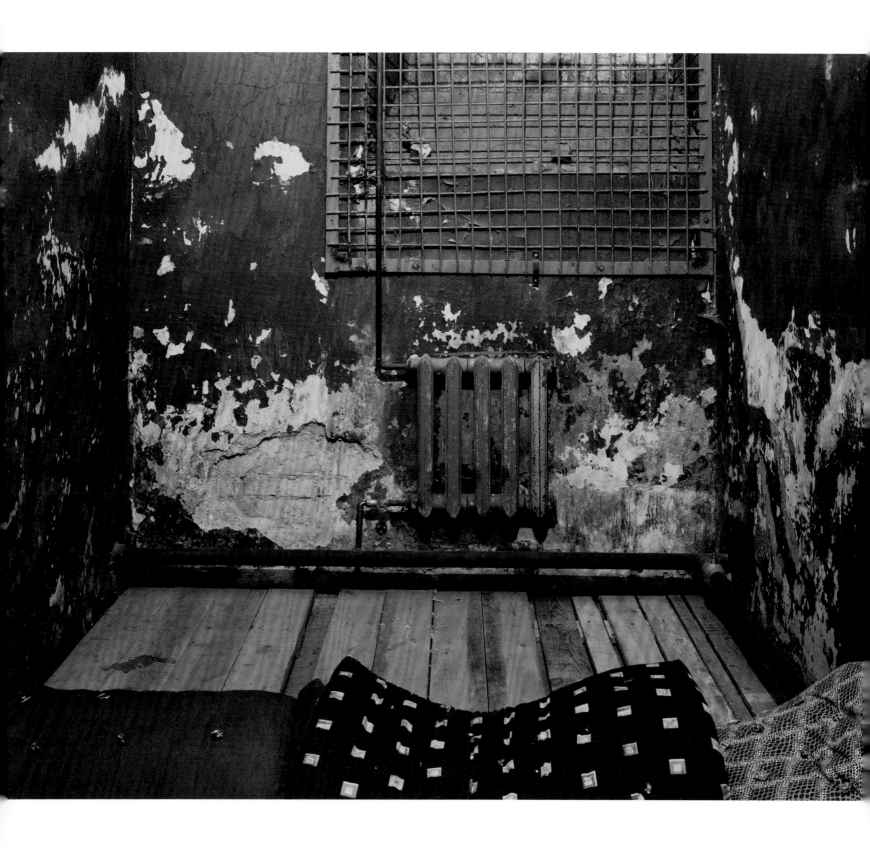

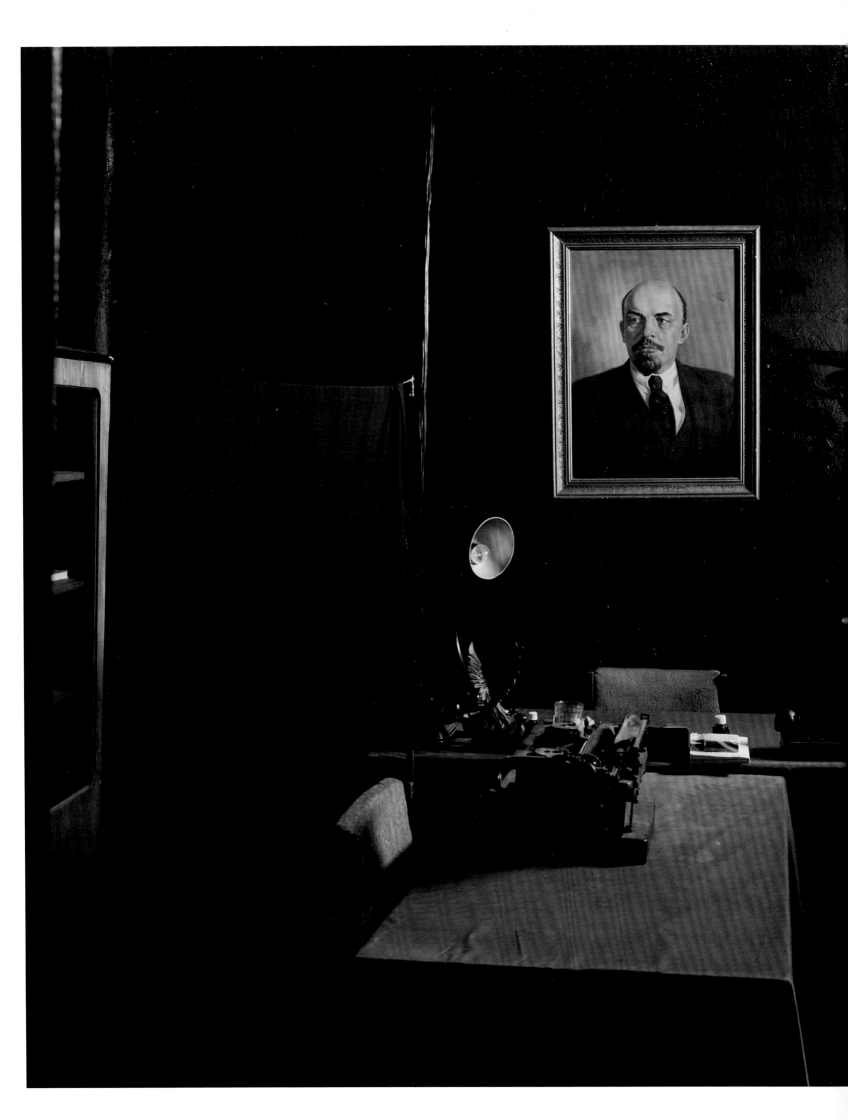

Karostas Cietums

Karostas Cietums. Extreme night

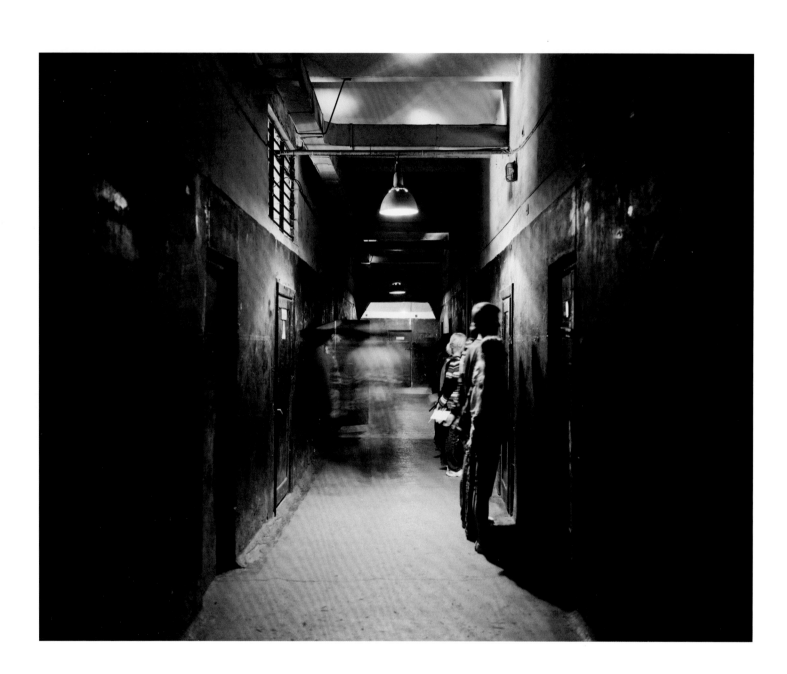

Karostas Cietums. Extreme night

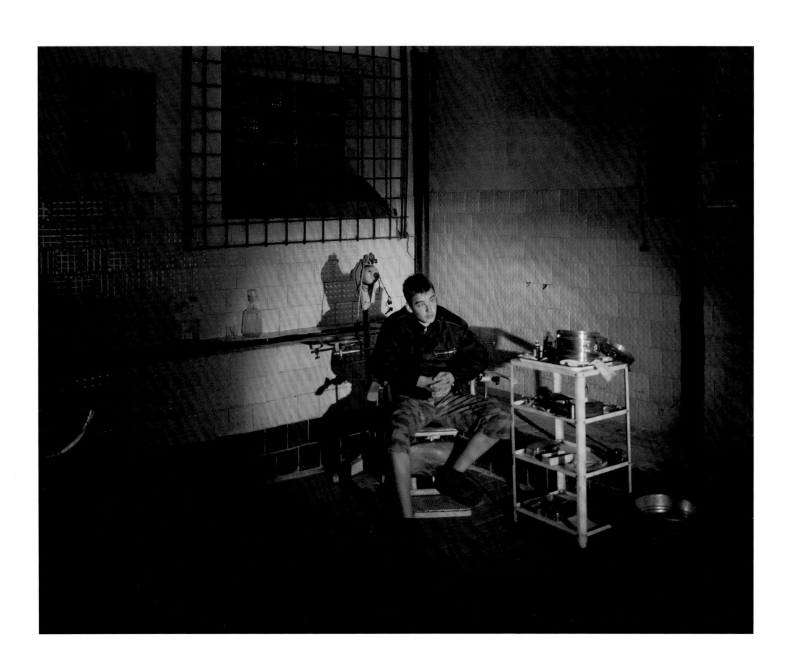

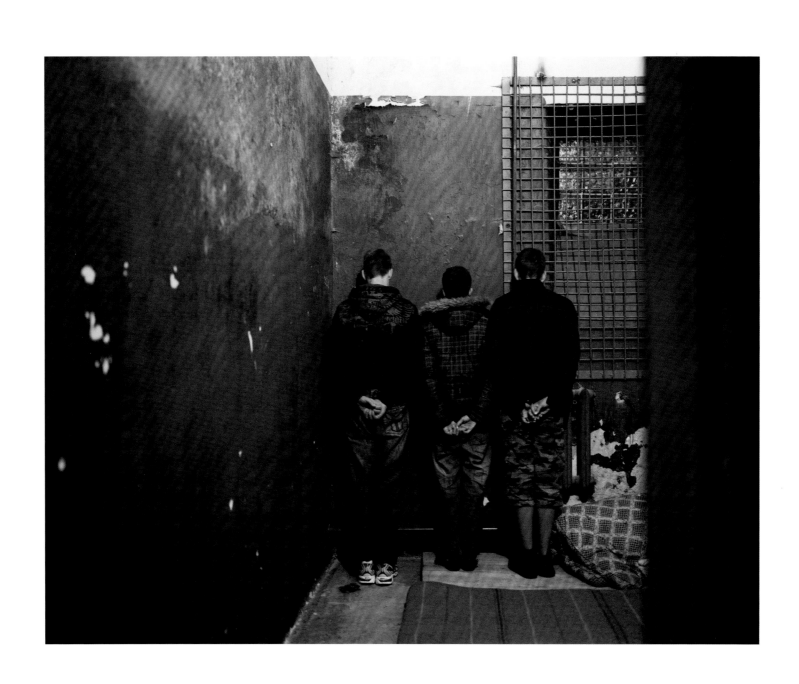

Karostas Cietums. Extreme night

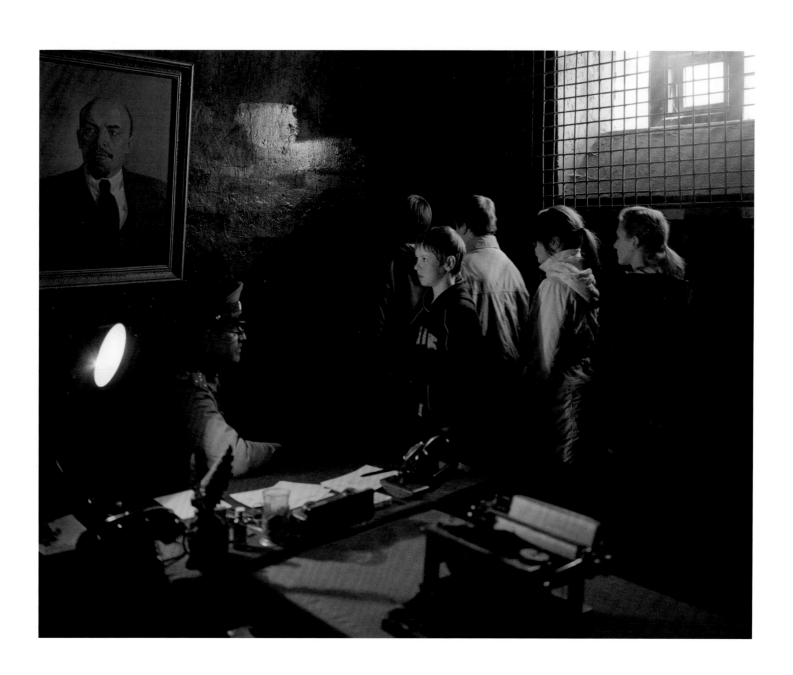

Karostas Cietums. Behind Bars: The Show

Karostas Cietums. Extreme night

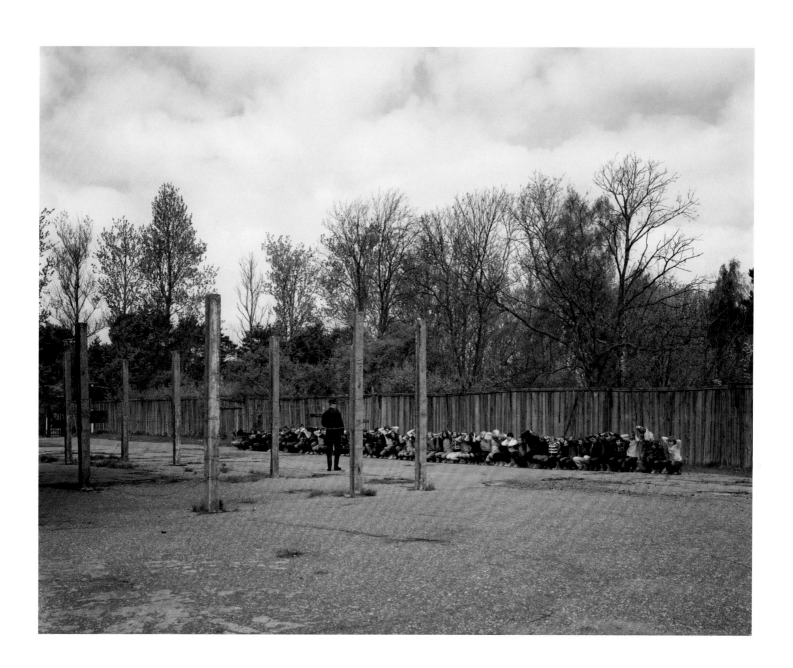

Escape from the USSR – Spy Game

The game takes place in the former Union of Socialist Soviet Republics (USSR) on the border zone which during that time was strictly controlled. Each evening, the beaches were raked so that in the morning the footprints of anyone trying to escape would be visible for the guards to see. Young people and foreigners might find it hard to fully grasp the idea that for soviet citizens to legally get out of the USSR was almost impossible. For those who could not accept living under the Soviet regime, all sorts of creative ideas came to mind to illegally escape the USSR. But for the most part, these attempts were unsuccessful. The Game: Work as a team to cross a number of obstacles, find a friend who is not able to get to safety alone and get them and your team to safety at the submarine. The team works on the principle of "all for one and one for all!" The most important thing about the game is teamwork, helping one another and providing a shoulder to those in need. In the Soviet border zone it is vital to be silent and move unnoticed and in secrecy. If one of the team members is noticed by a border guard, an alarm will sound and the operation will be considered a failure and incomplete. If participants suffer from asthma, claustrophobia or other disorders that may affect performance in the game, we ask that the organisers be informed in advance. Before the game begins, each participant is asked to sign a waiver form that acknowledges that they are responsible for their own safety, are not under the influence of drugs or alcohol and will care for the supplies and equipment provided during the game.

(Source: Karostas cietums, Latvia)

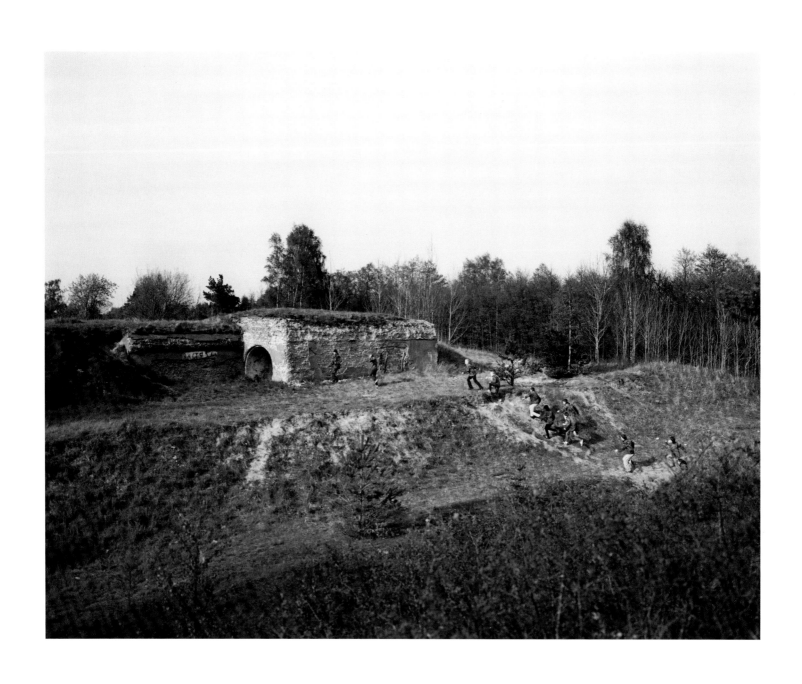

'Escape from USSR' Spy Game

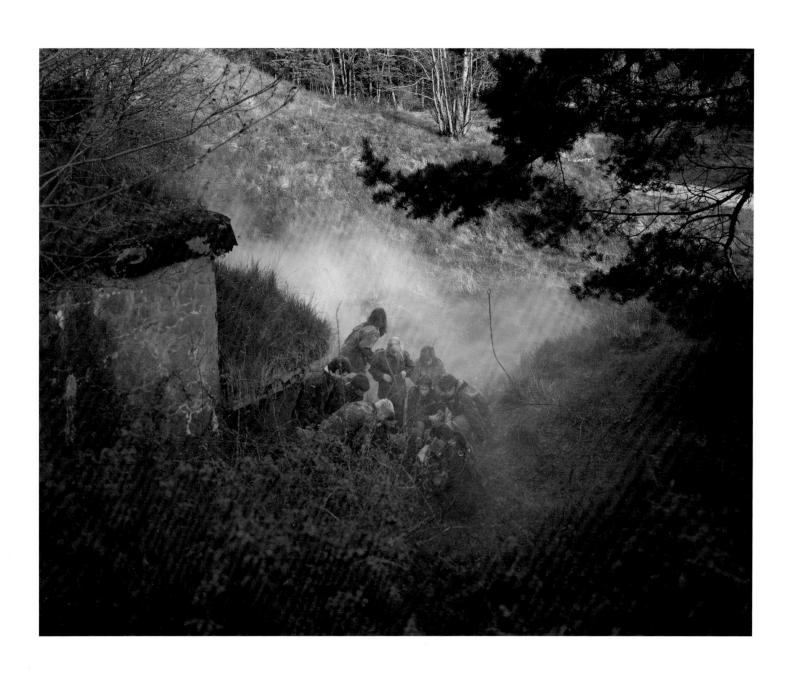

'Escape from USSR' Spy Game

Trip to Chernobyl – Ukraine

Visit the site of the worst environmental disaster in history
Ecological / Extreme tourism

The Chernobyl zone is a closed zone in radius of 30 km from Chernobyl station. There are a lot of green parks and lawns, but it's sad to realize that children don't play there any more. Entrance to this zone is possible only with the help of permits, which we receive for our tourists in the Ministry of Nuclear Industry. In the territory tourists who arrive to Chernobyl examine fire department and the monument to fire men who were engaged in fire extinguishing on 4th block CHAES. After that tourists will see construction blocks for the burial place of nuclear waste (by the way, they were built by a French building company). After that tourists go to a museum of Chernobyl tragedy and have opportunity to be photographed against background of the 4th reactor on a small distance. The Chernobyl accident happened exactly on this reactor and now it is closed by a sarcophagus. This trip is interesting for its true telling how everything was indeed. The facts about this accident shock every person who visits this 'exclusion zone'. The tourists will also hear about city Pripyat which has been left by inhabitants (51000 persons) within 1 day. During the excursion you will have an opportunity to take wonderful pictures, make a video and listen to the story about the life in the town before the accident, the evacuation itself, the history of the town and its life till today.

(Source: SAM travel, Ukraine)

Trip to Chernobyl
Acquaintance with the peace and quiet of the ghost town Prypyat
The amusement park

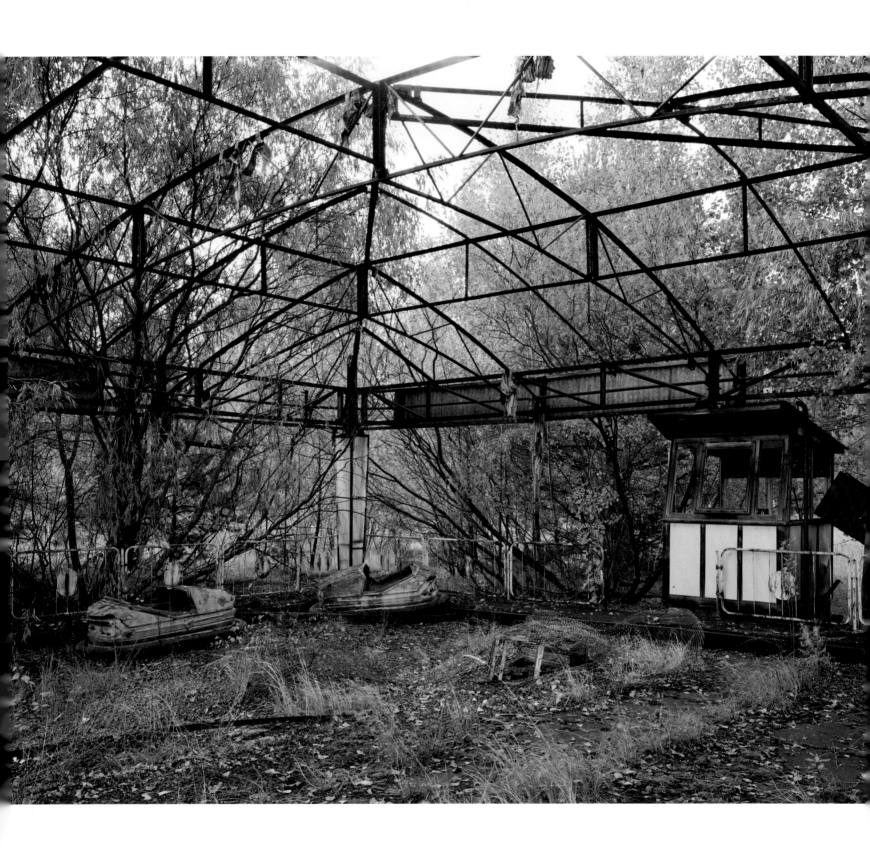

Trip to Chernobyl
Examination of the abandonned apartment blocks, schools, hotels, kindergartens

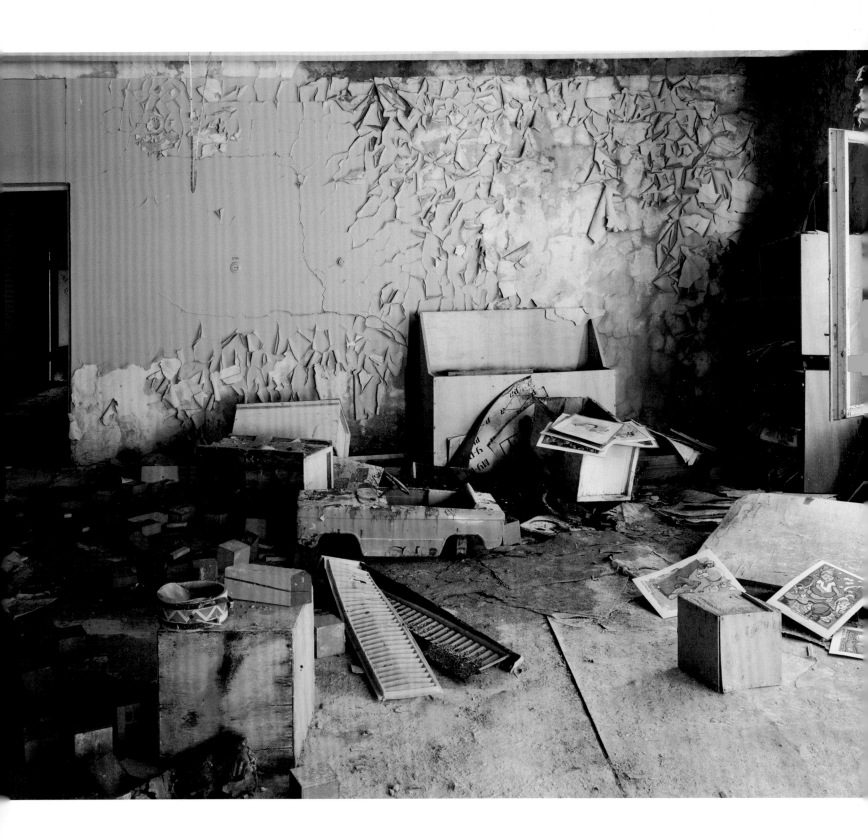

Trip to Chernobyl
Examination of the abandoned apartment blocks, schools, hotels, kinder gardens

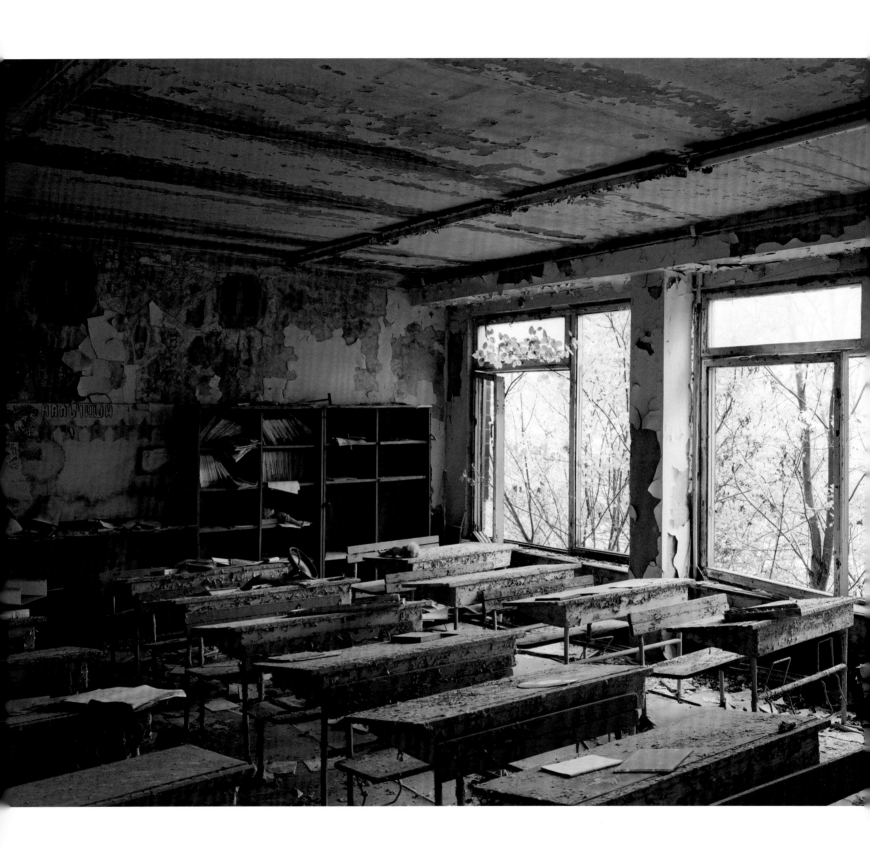

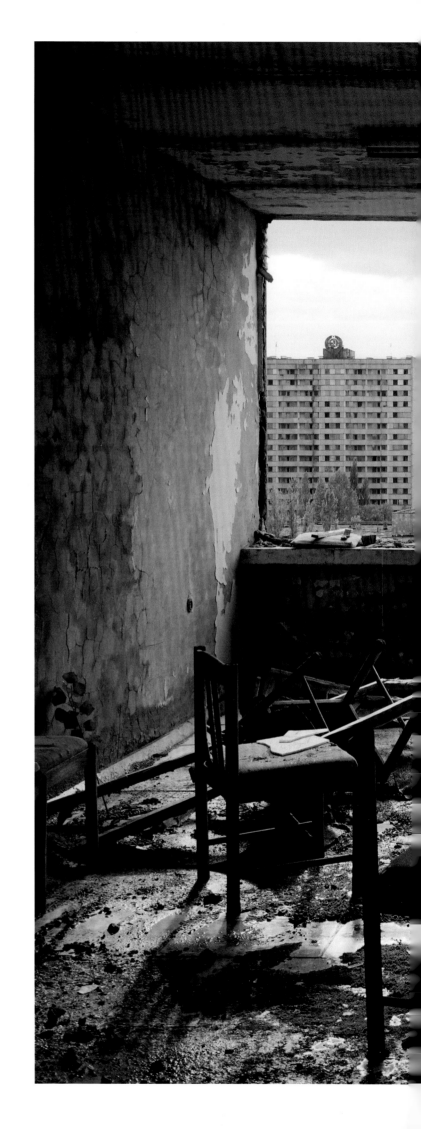

Trip to Chernobyl
The empty ghost town of Pripyat.
The central town hotel 'Polessye'

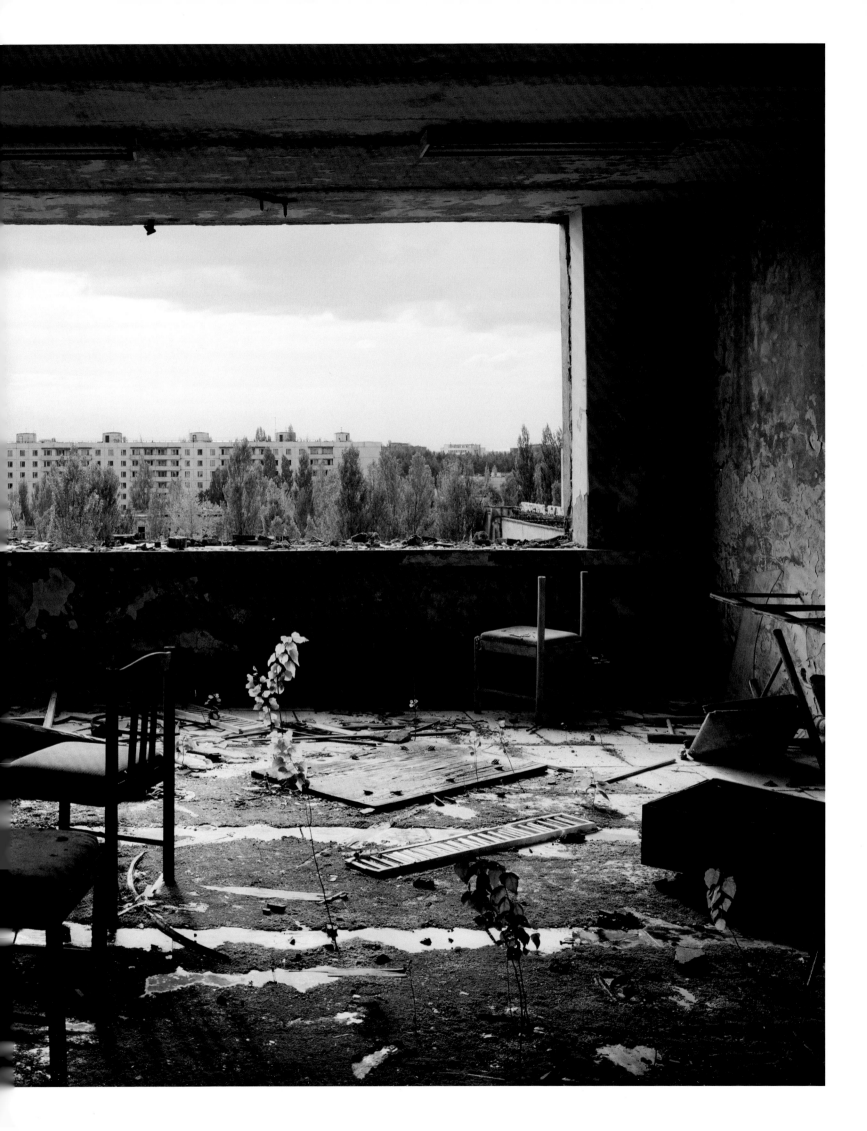

Trip to Chernobyl
Lunch (the quality of food is guaranteed)

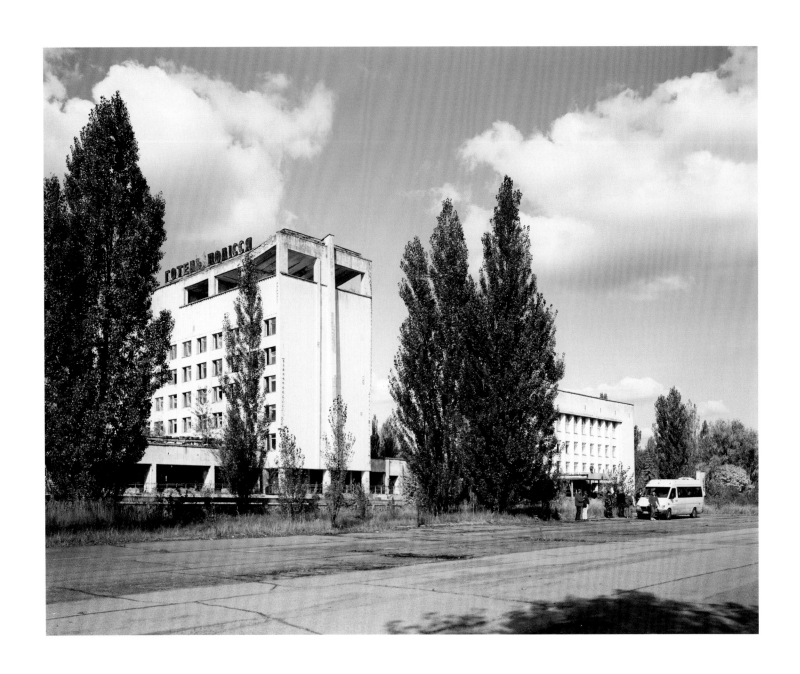

Trip to Chernobyl
The empty ghost town of Pripyat. The central town hotel 'Polessye'

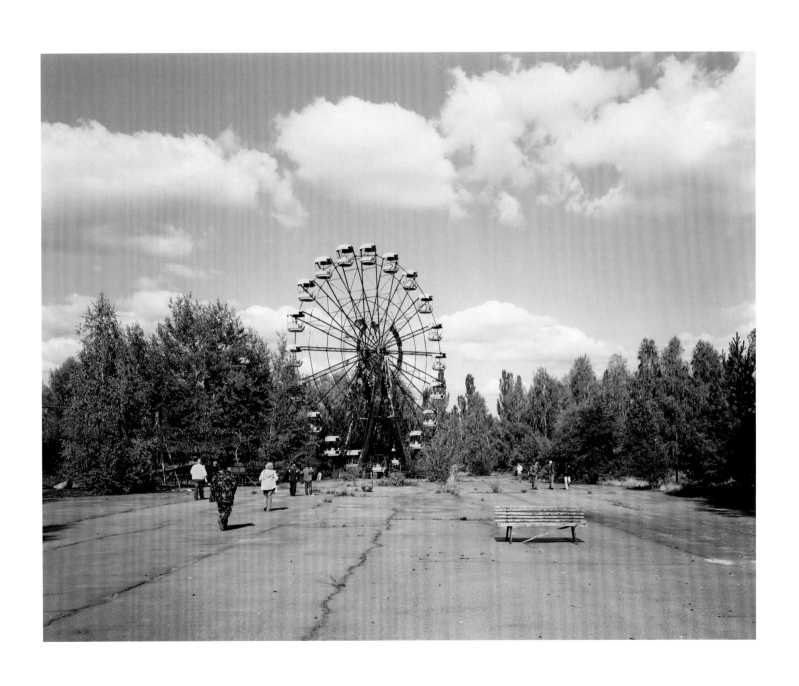

Trip to Chernobyl
The empty ghost town of Pripyat. The amusement park

Trip to Chernobyl
The empty ghost town of Pripyat. Examination of the abandonned apartment blocks

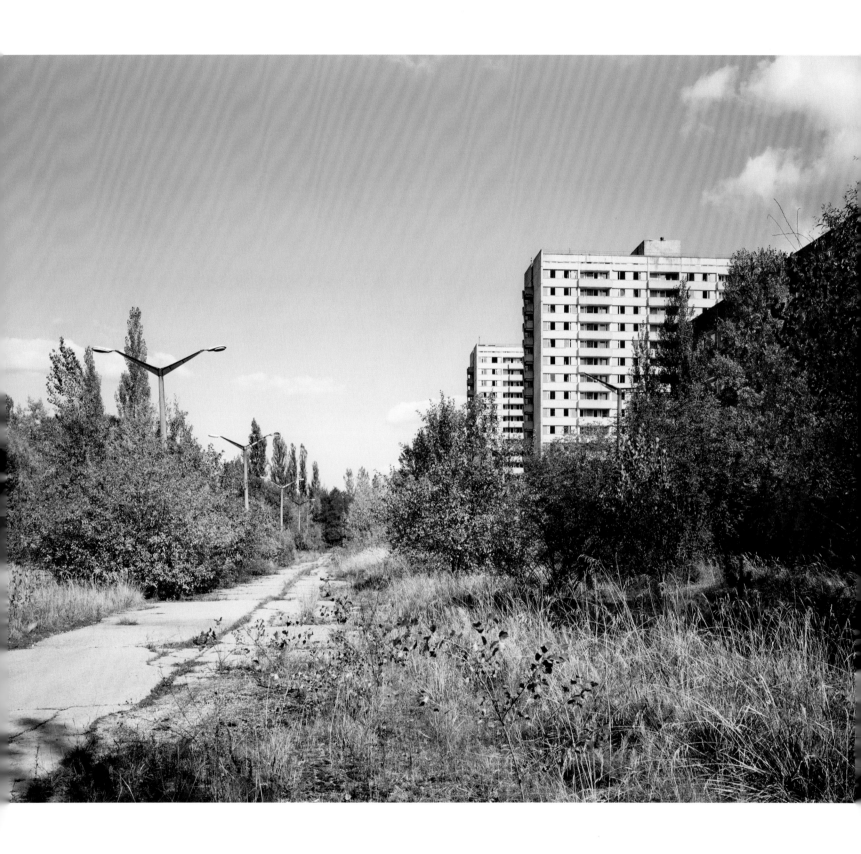

Trip to Chernobyl
We will make the round tour of the power plant and make a stop near the gates of the 4th power unit on the special observation platform with the view of the 'Sarkofag (sarcophagus)' site

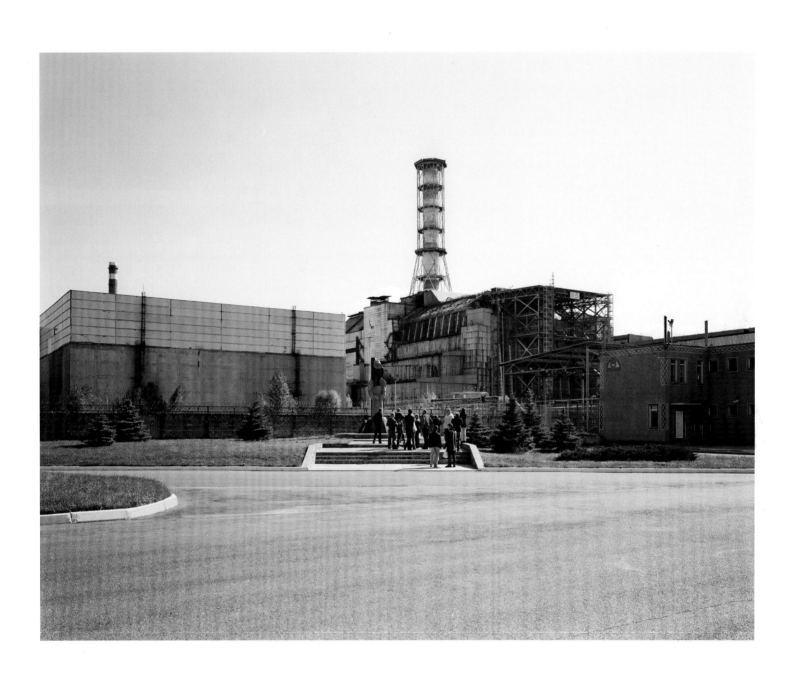

Genocide Memorial Tour – Rwanda

The Gorilla Safari Genocide Memorial tour takes you for a short historical tour of Rwanda in Kigali city, visit Rwanda Genocide memorial sites and Gorilla trekking in the Volcanoes national park of Rwanda. The tour starts and ends in Kigali; after gorilla trekking in the Volcanoes national Park, you will transfer back to Kigali for your flight/ End of the safari.

(Source: Africa Adventures Safaris LTD, Uganda)

The Kigali Memorial Centre is an international centre. It deals with a topic of international importance, with far-reaching significance, and is designed to engage and challenge an international visitor base. The response from genocide survivors to the creation of the Centre was unpredicted. In the first week, over 1,500 survivors visited each day. In the first three months of the Centre's opening, around 60,000 people from a variety of backgrounds visited it. Over 7,000 of these visitors were from the International Community.

(Source: Kigali Memorial Centre, Rwanda)

Rwanda Genocide Memorial Tour
Ntarama genocide memorial site

Rwanda Genocide Memorial Tour
Burial Chambers, Kigali Memorial Centre

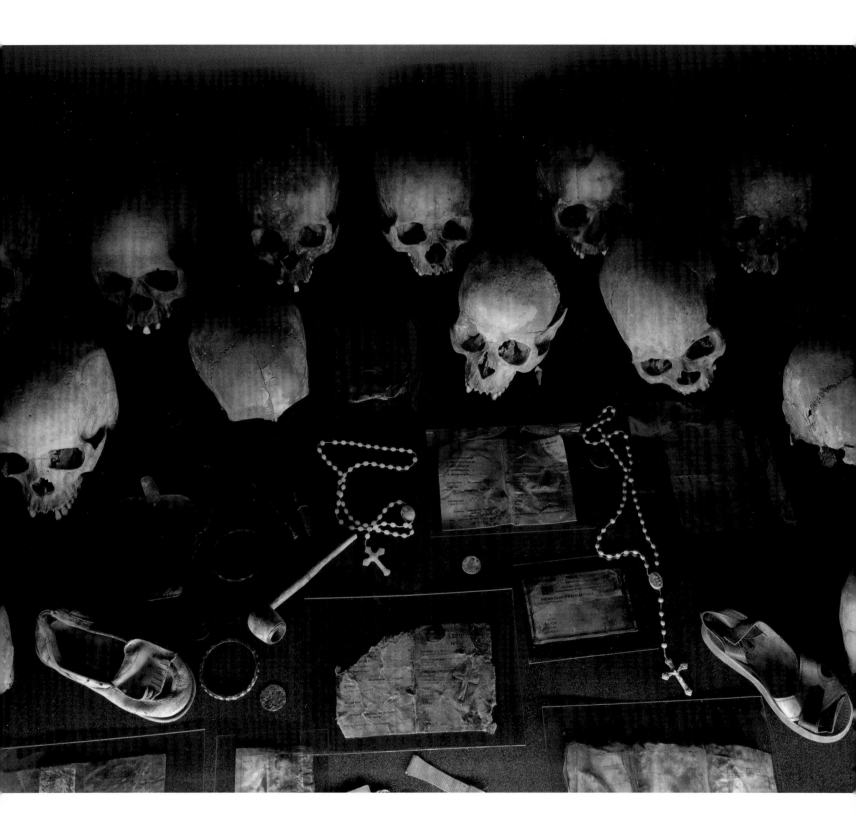

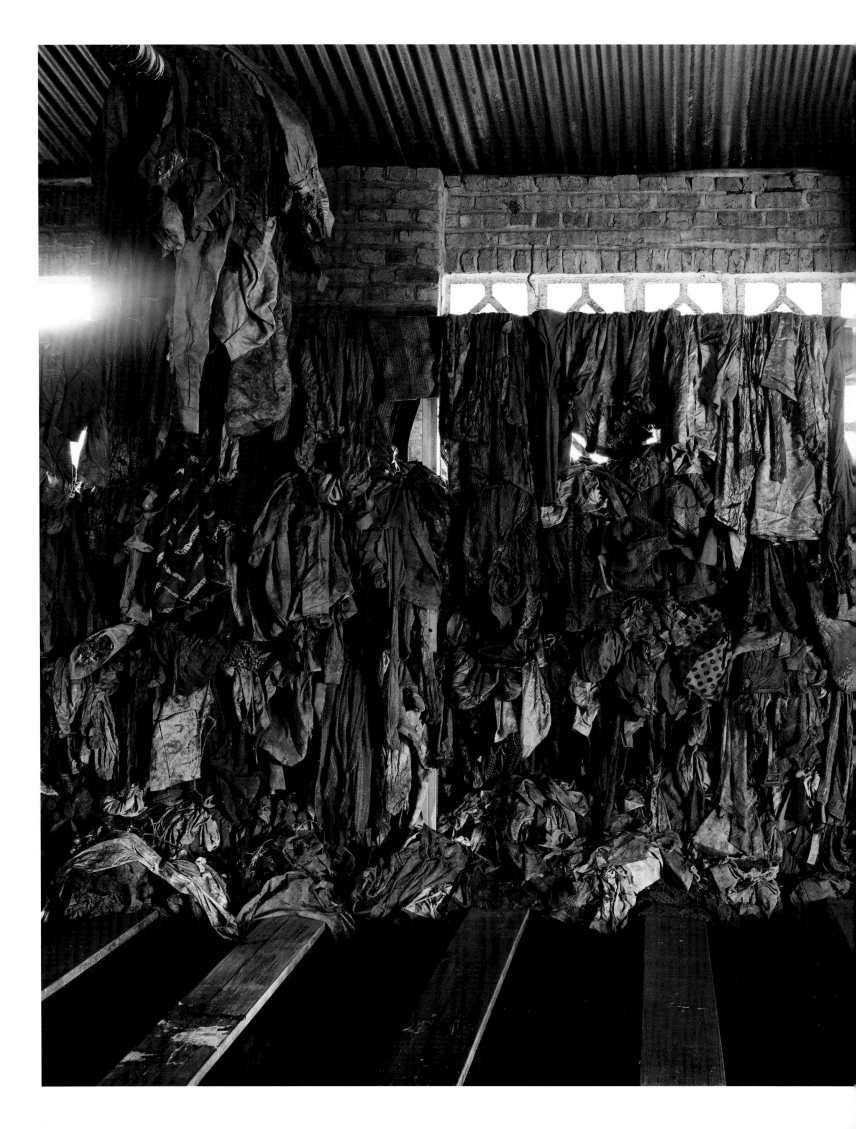

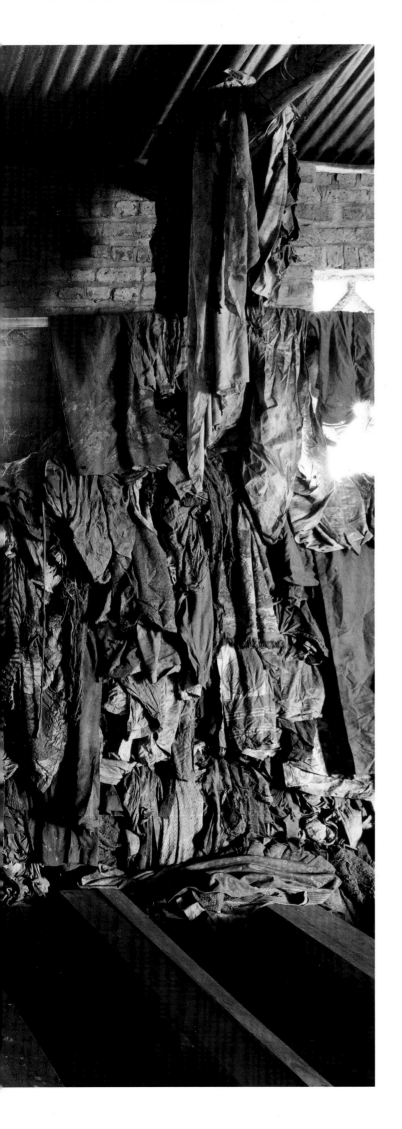

Rwanda Genocide Memorial Tour
Ntarama genocide memorial site

Rwanda Genocide Memorial Tour
Ntarama genocide memorial site

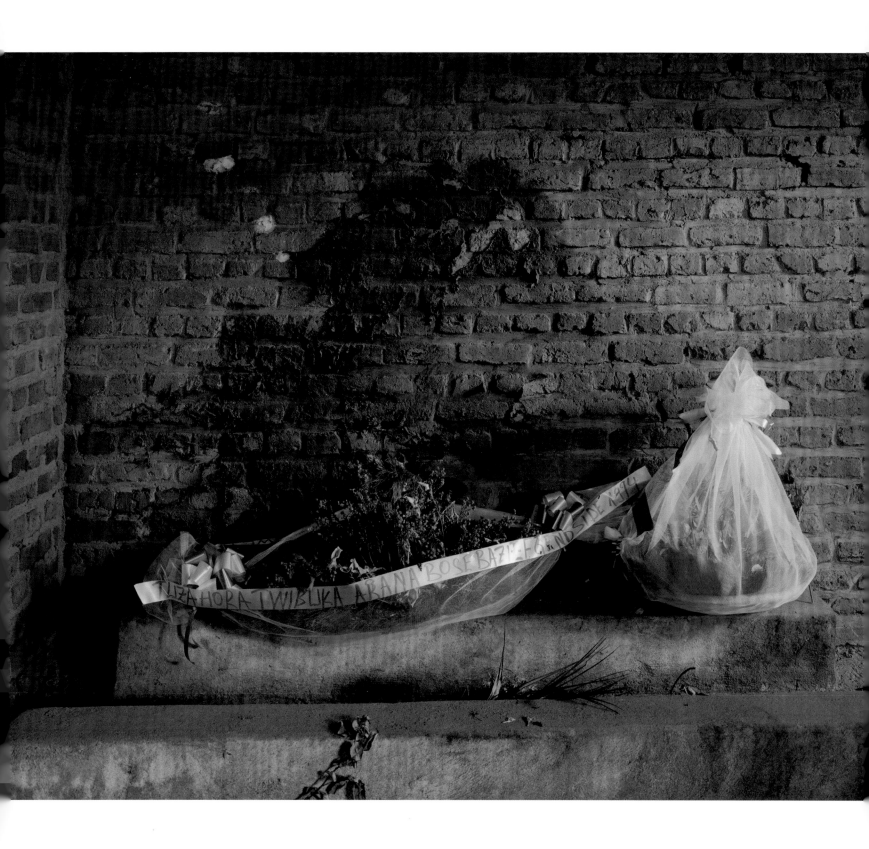

Rwanda Genocide Memorial Tour
Bisesero genocide memorial site

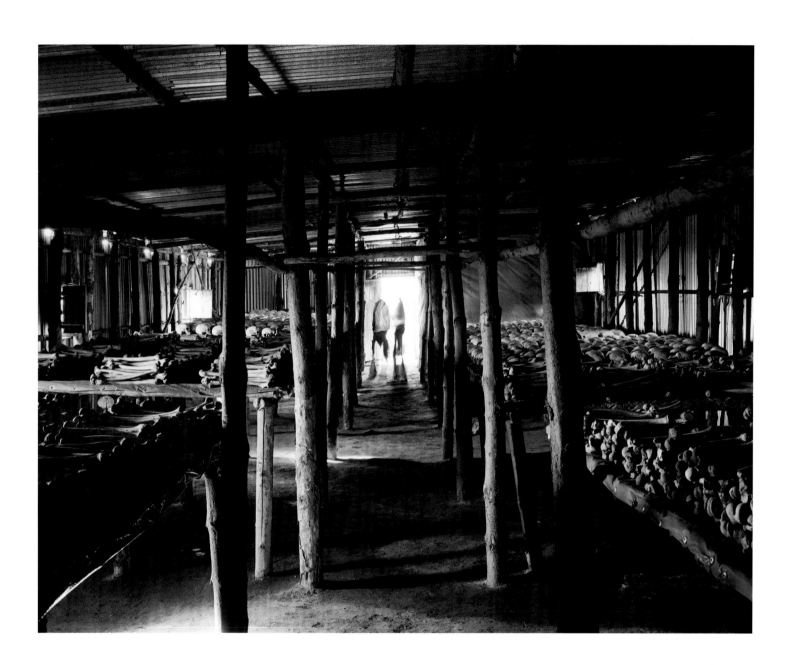

Rwanda Genocide Memorial Tour
Bisesero genocide memorial site

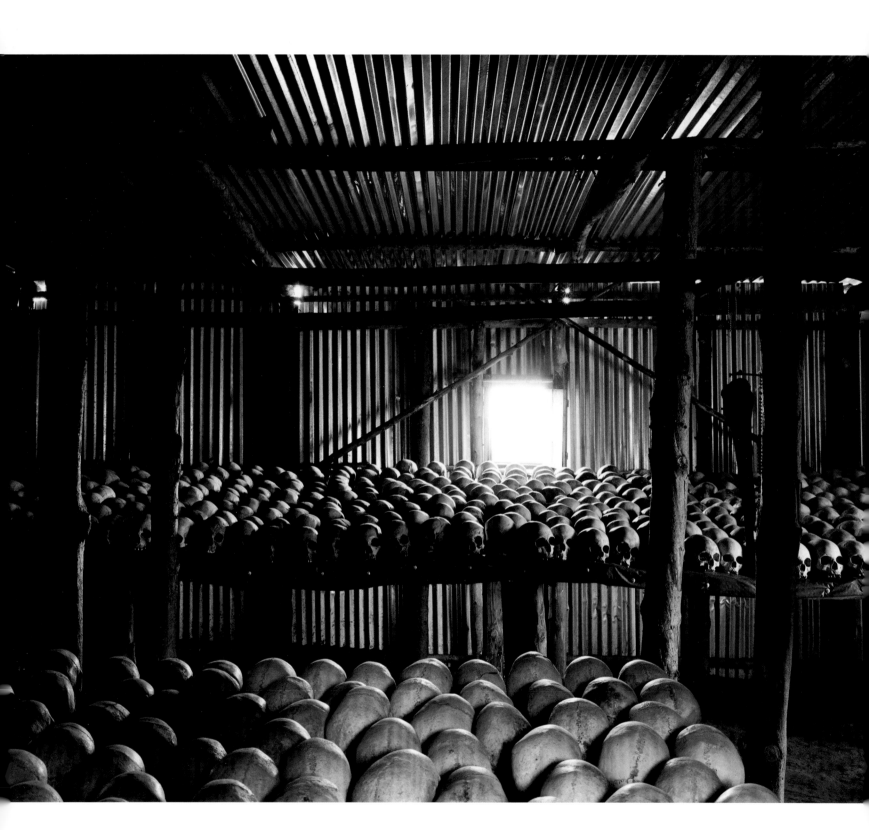

Rwanda Genocide Memorial Tour
Murambi genocide memorial site

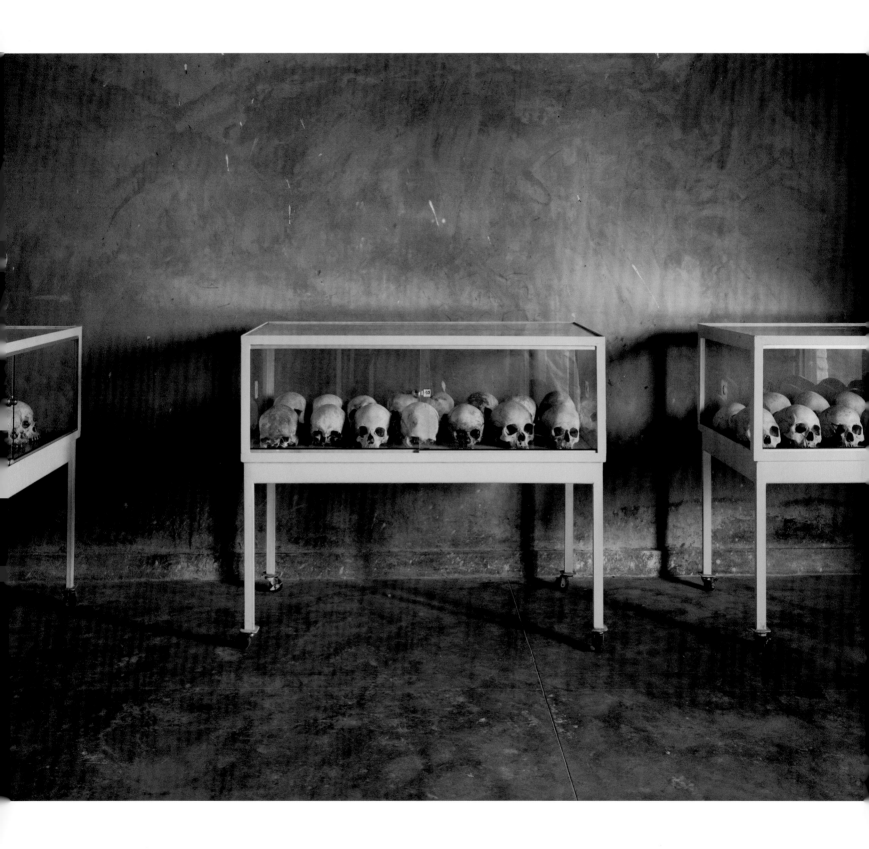

Rwanda Genocide Memorial Tour
Room of clothes. The final exhibit on the ground floor is in a room
displaying the clothes worn by victims as they died. Kigali Memorial Centre

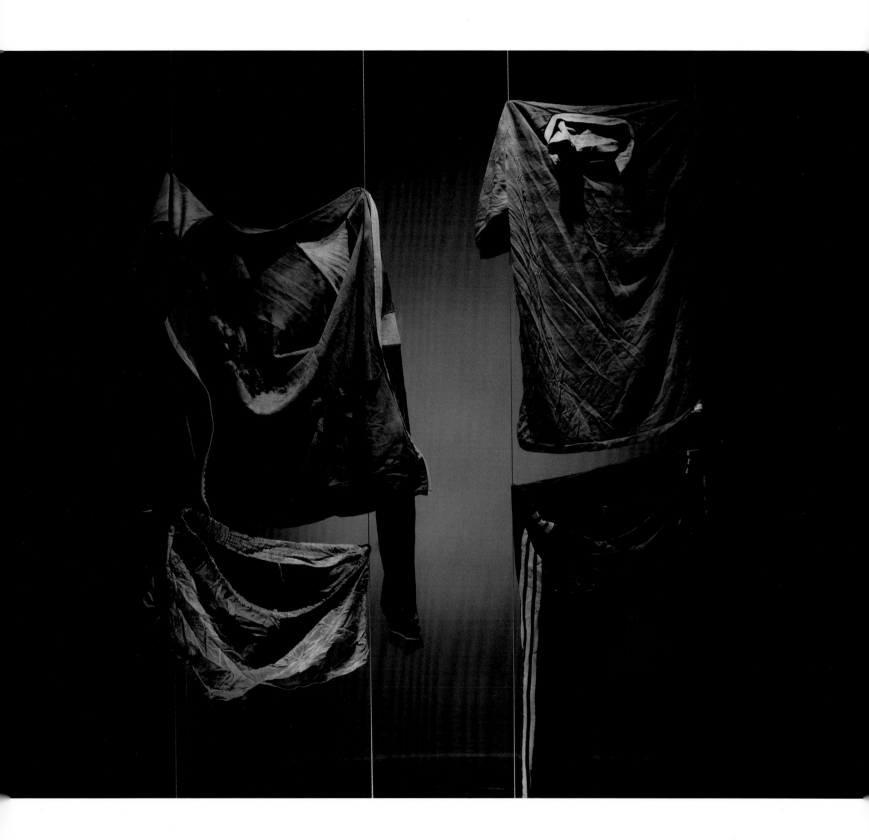

Rwanda Genocide Memorial Tour
Bisesero genocide memorial site

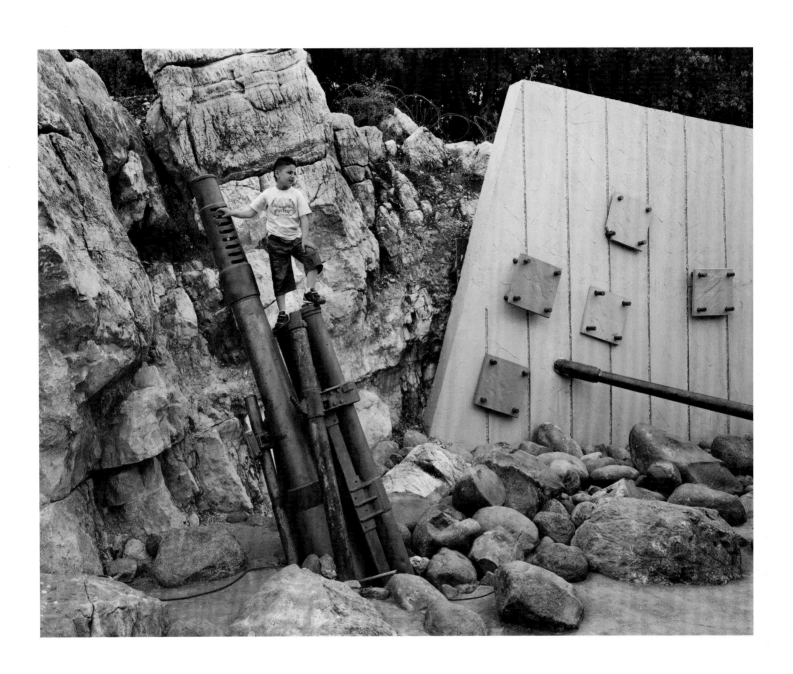

Mleeta Resistance Tourist Landmark

The Cave: One of the posts that was built by the resistance fighters for shelter. It was dug in rotation by more than 1000 freedom fighters over a span of 3 years. It is 200 meters deep and holds different chambers and provisions. More than 7000 resistance fighters had garrisoned in that post. Command room.

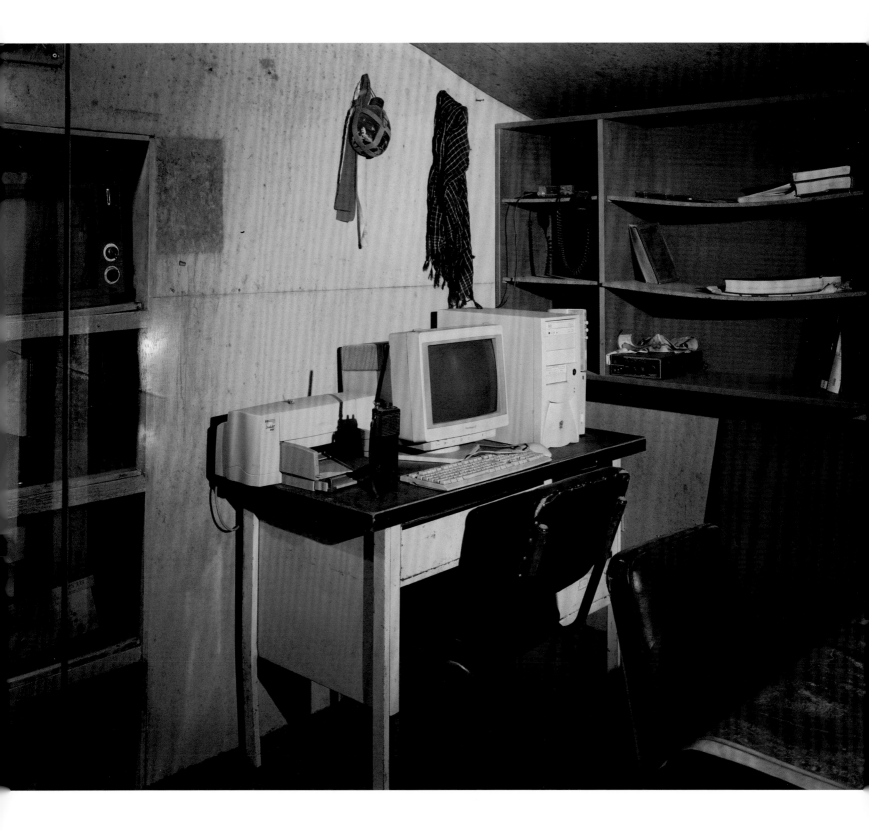

The Cave: One of the posts that was built by the resistance fighters for shelter. It was dug in rotation by more than 1000 freedom fighters over a span of 3 years. It is 200 meters deep and holds different chambers and provisions. More than 7000 resistance fighters had garrisoned in that post. Kitchen.

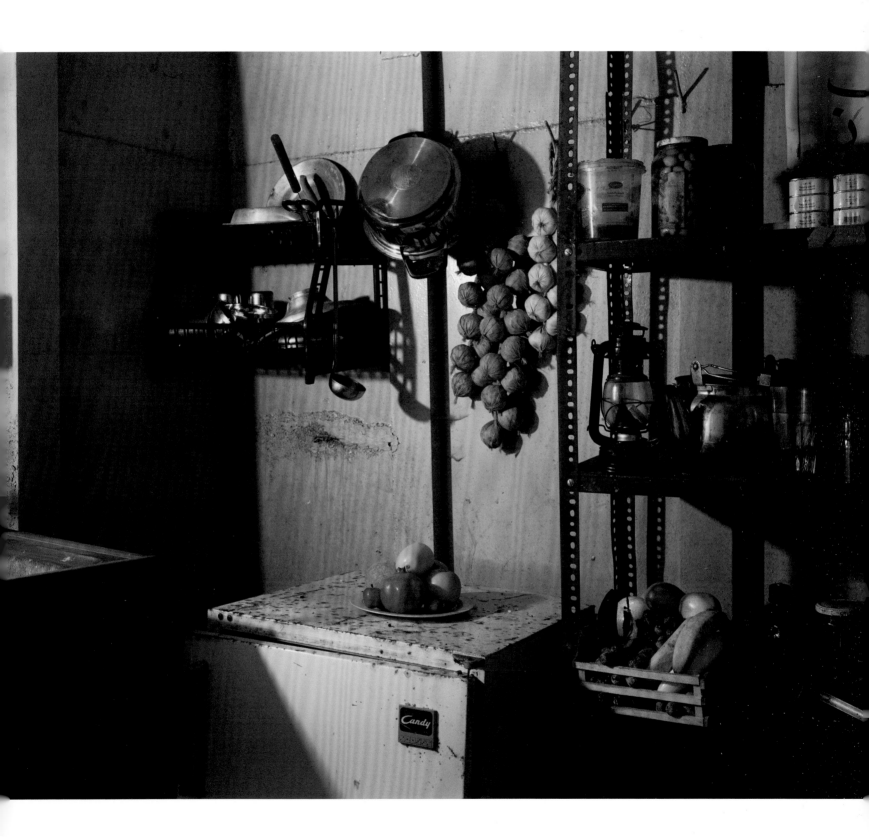

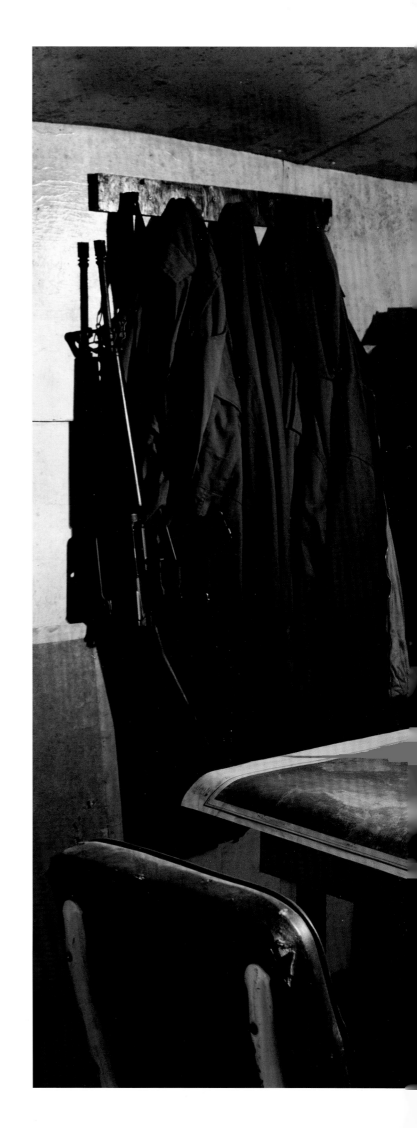

Mleeta Resistance Tourist Landmark
The Cave: One of the posts that was built by the resistance fighters for shelter. It was dug in rotation by more than 1000 freedom fighters. It is 200 meters deep and holds different chambers and provisions. More than 7000 resistance fighters had been garrisoned in that post. Command room.

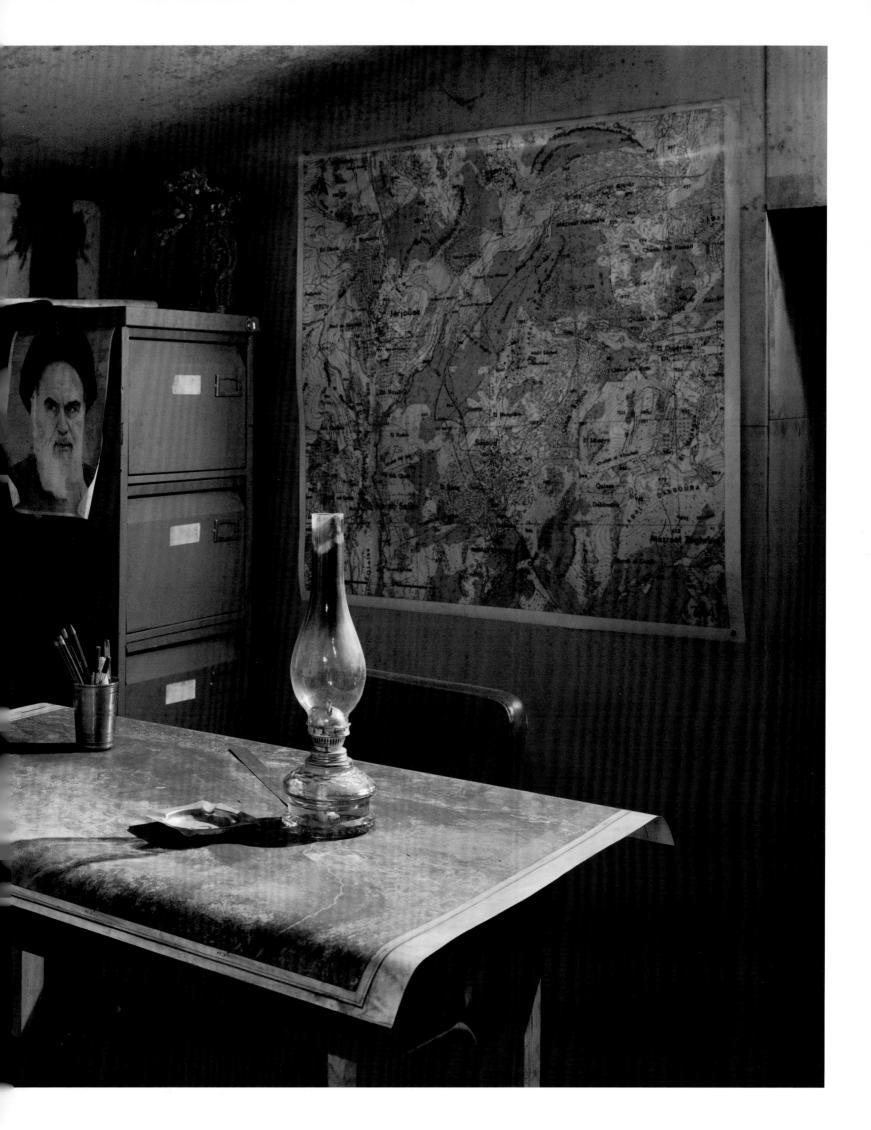

Mleeta Resistance Tourist Landmark

The Pathway: A rugged bushy trail where thousands of Mujahedeen had positioned during the years of occupation. From there, they launched to execute military operations against the opposing enemy outposts, reaching the occupied buffer zone. This trail demonstrates different combative scenes of the resistance fighters on a slope of 250 meters in length.

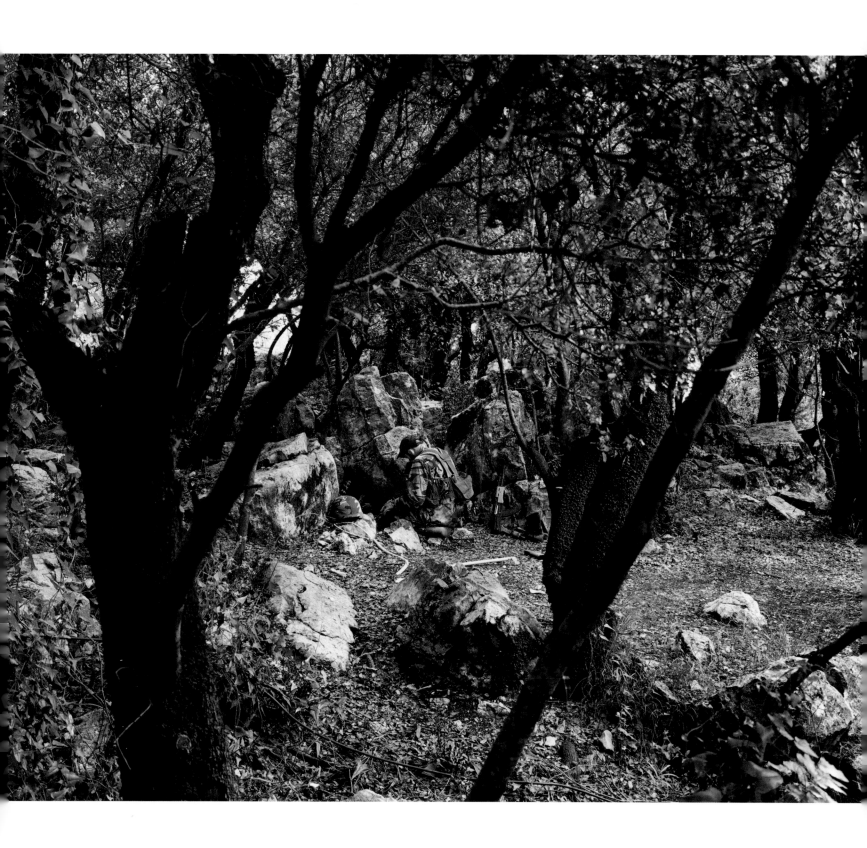

Liberation Square: Forms an open space for gathering and resting with different models of the resistance weapons placed along its sides

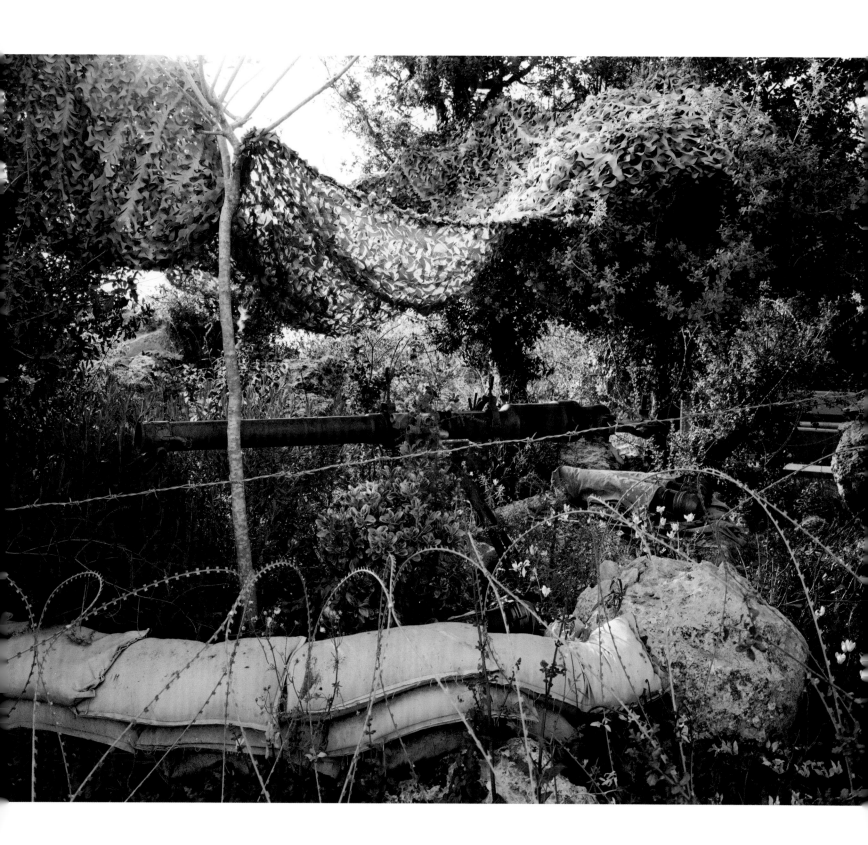

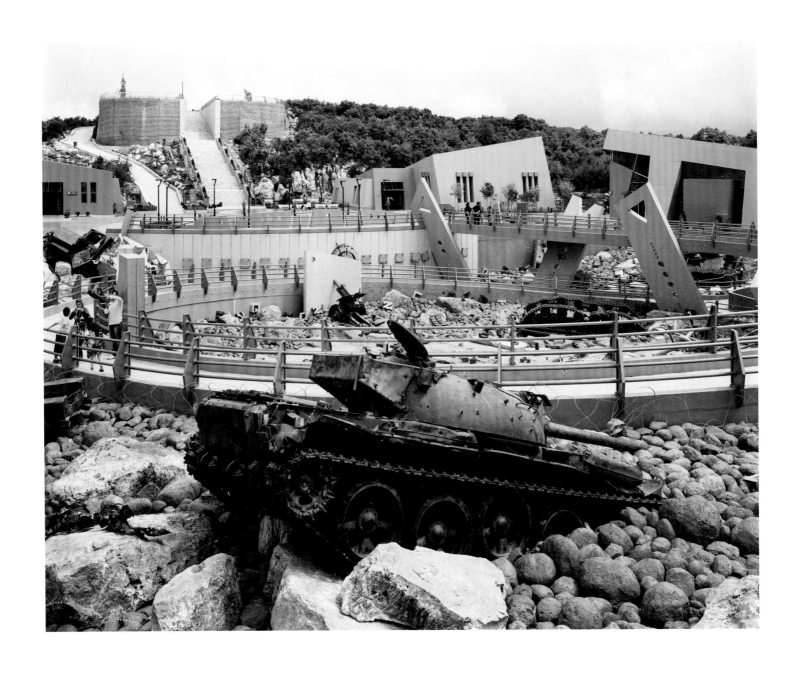

Mleeta Resistance Tourist Landmark

The Abyss: A structural scenic art that is built on a 3000 m2 area, materializing the Zionist defeat. It has been formed of several armed vehicles and weapons of the Israeli enemy army and its army of collaborators. These items have been gained by the resistance since 1982 until the July war of 2006.

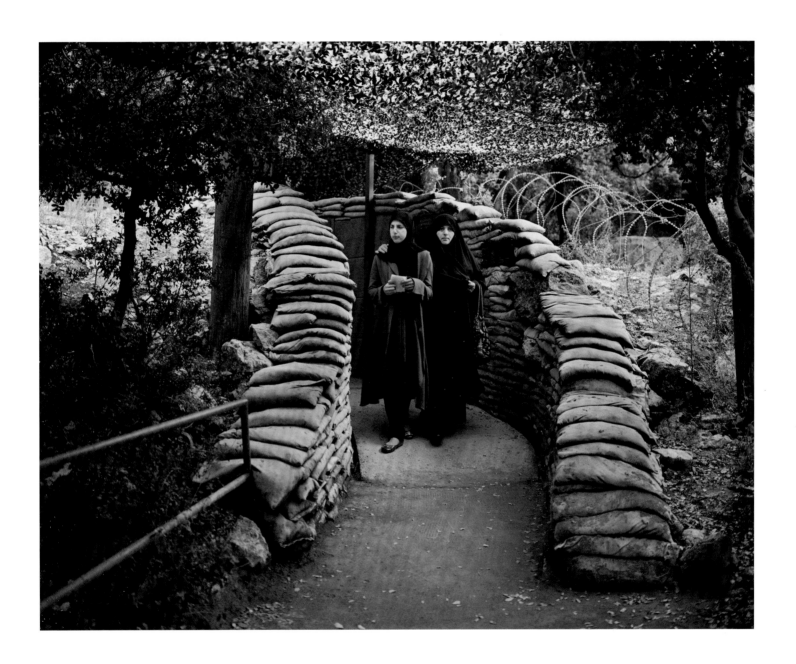

Mleeta Resistance Tourist Landmark
The Pathway: A rugged bushy trail where thousands of Mujahedeen had positioned during the years of occupation.
From there, they launched to execute military operations against the opposing enemy outposts, reaching the occupied
buffer zone.

Mleeta Resistance Tourist Landmark
Frontline Guarding: A preventive military mission with an aim to secure the resistance locations and frontline villages against enemy infiltrations. Tens of thousands of resistance fighters kept this mission active over the past years of occupation, year-round, day and night.

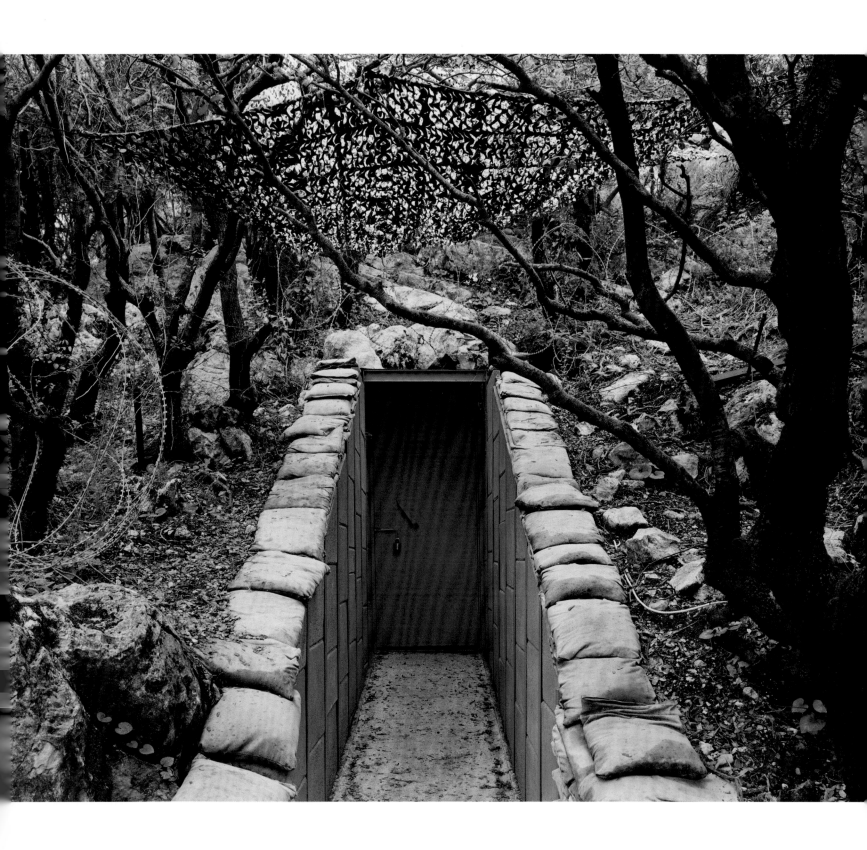

Mleeta Resistance Tourist Landmark

The Abyss: A structural scenic art that is built on a 3000 m2 area, materializing the Zionist defeat. It has been formed of several armed vehicles and weapons of the Israeli enemy army and its army of collaborators. These items have been gained by the resistance since 1982 until the July war of 2006.

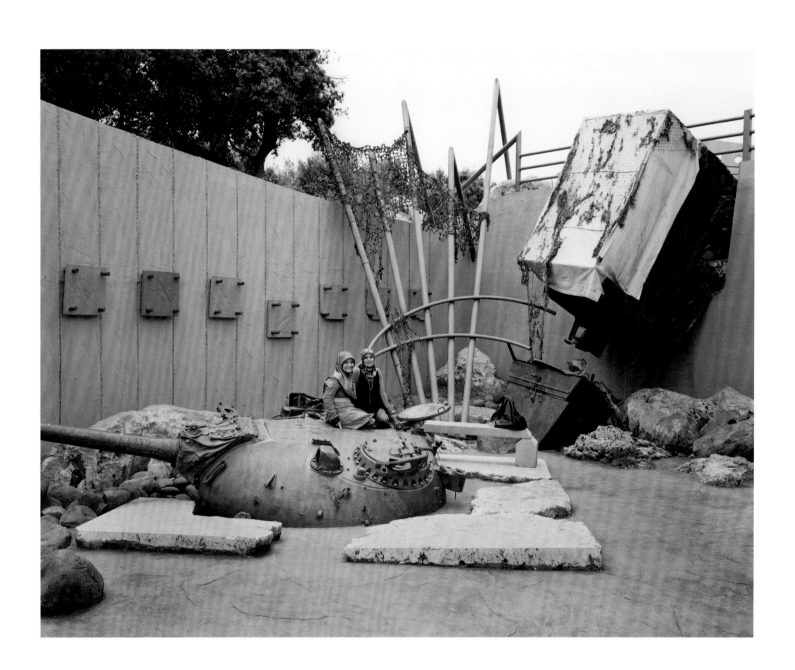

Mleeta Resistance Tourist Landmark
Gift Shop: designed for selling souvenirs and gifts relating to the resistance

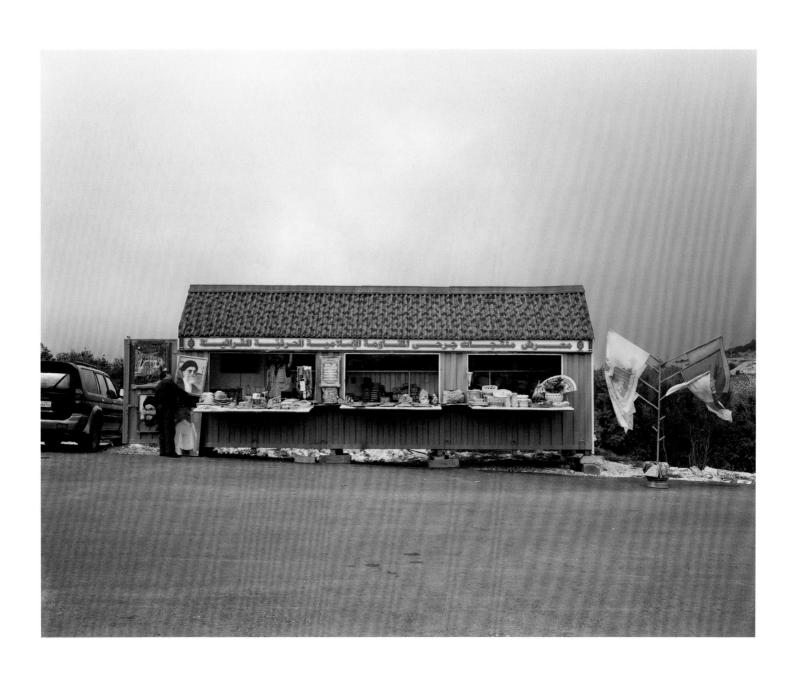

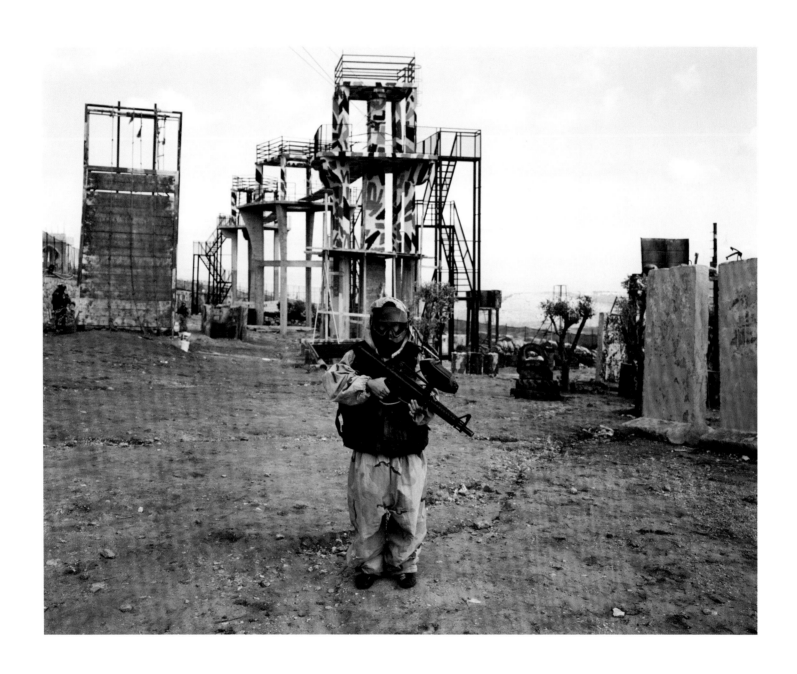

Paintball arena

Maroun Al-Ras park – Lebanon

Iran designed and opened a public garden in South Lebanon, in the village of Maroun Al Ras near Palestinian occupied borders, where, thanks to Iran, greenery is everywhere to be found

(Source: Islamic Resistance in Lebanon – official website).

"The Iranians gave it [the park] as a gift for the martyrs of Maroun Al Ras. The idea was to show the enemy that not only are we masters of war, but we are also masters of beauty. It's a spot where you feel pride that you can stand and reach out and grab Palestine with your hand."

(Ibrahim Allawi, Mayor of Maroun Al Ras)

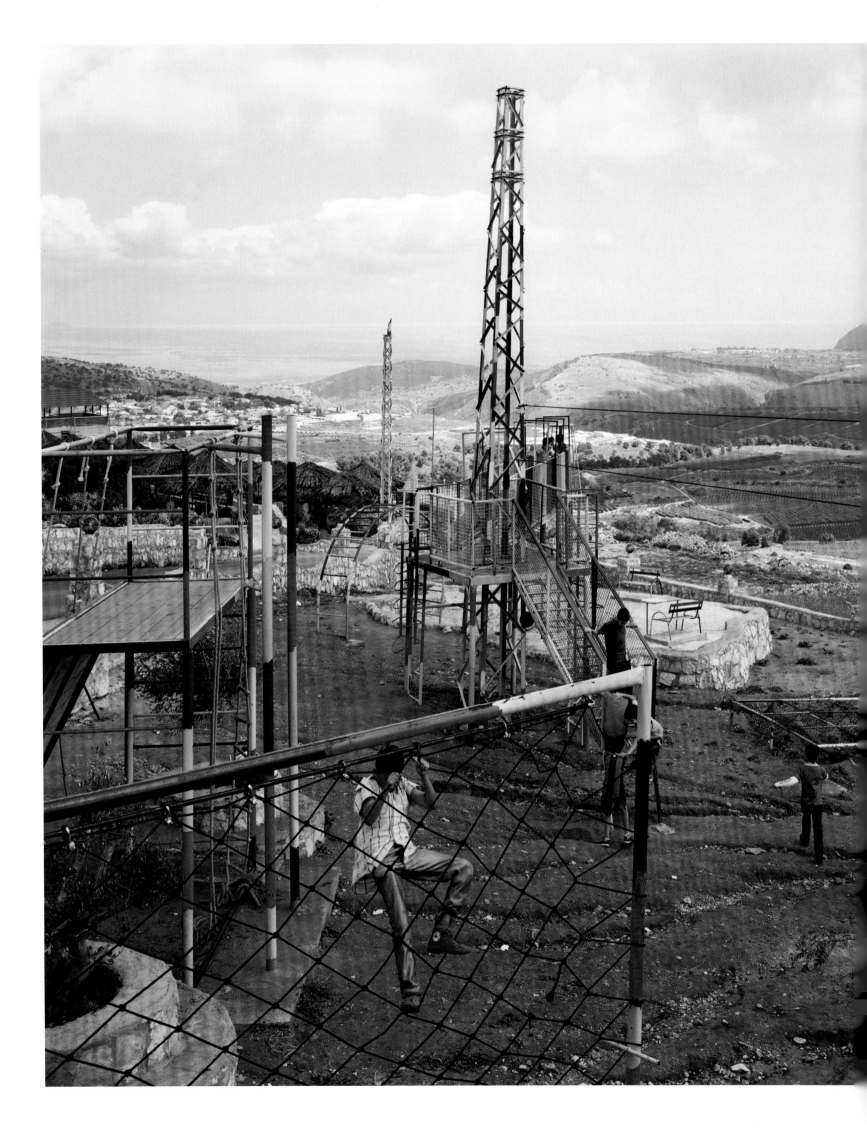

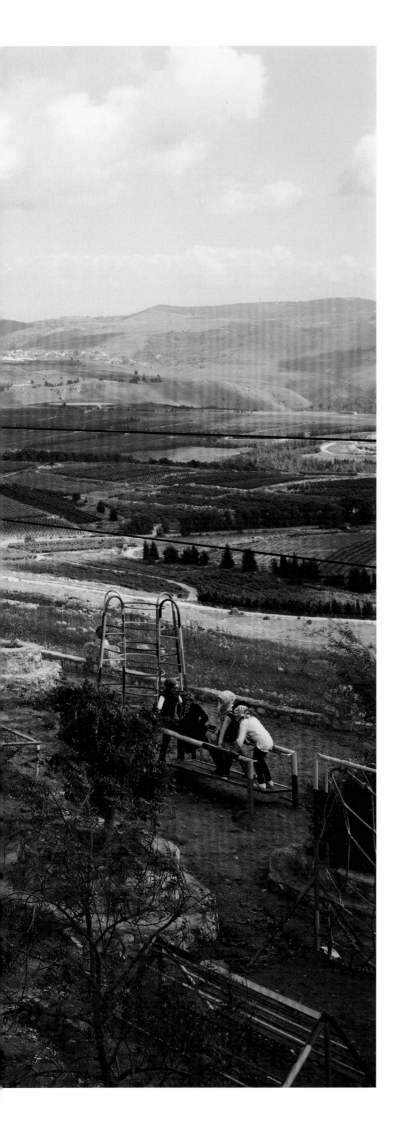

Maroun Al-Ras park. Playground

Sichuan Wenchuan earthquake ruins tour - China

Experience witness the damages of the deadliest
Wenchuan earthquake in recent history

It is known to us, the day on May 12th, 2008 brought great misfortune to Sichuan people and to the whole China. Everyone in the world was astonished by the gigantic earthquake happened in Wenchuan, Sichuan Province. The houses were destroyed and a large number of people lost their life. This tour will offer you a chance to experience places where the earthquake happened and to have a look at the situation after the tremendous earthquake. I am a tourguide, my name is Zhongwen (male, speaking German and English, a little French, worked 22 years in travel agent, manager of Sichuan China Travel Service, the eldest and biggest travel agent in Chengdu), the driver names Wu.

(Source: Sichuan Travel Service, China)

Sichuan Wenchuan earthquake ruins tour
Broken Yiwanshui village in earthquake lake

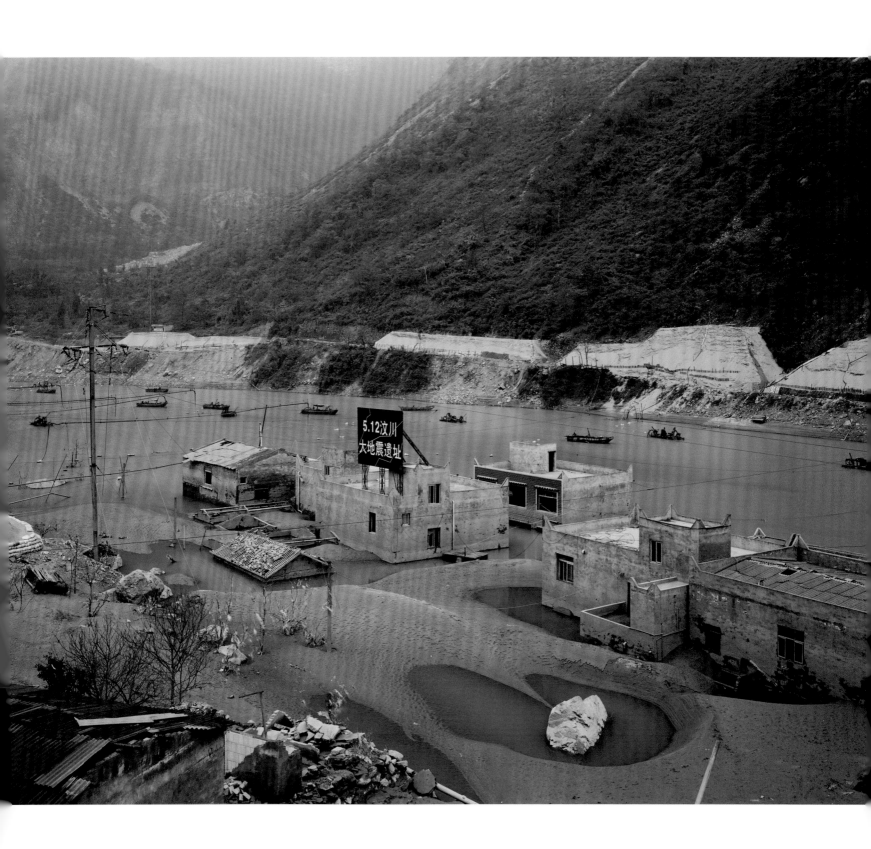

Sichuan Wenchuan earthquake ruins tour
Earthquake Ruins, Shifang (county-level city, about 5924 died, 214 lost, 33027 wounded)
Sichuan Province Shihua Stock CO., LTD and Yinghua stock company

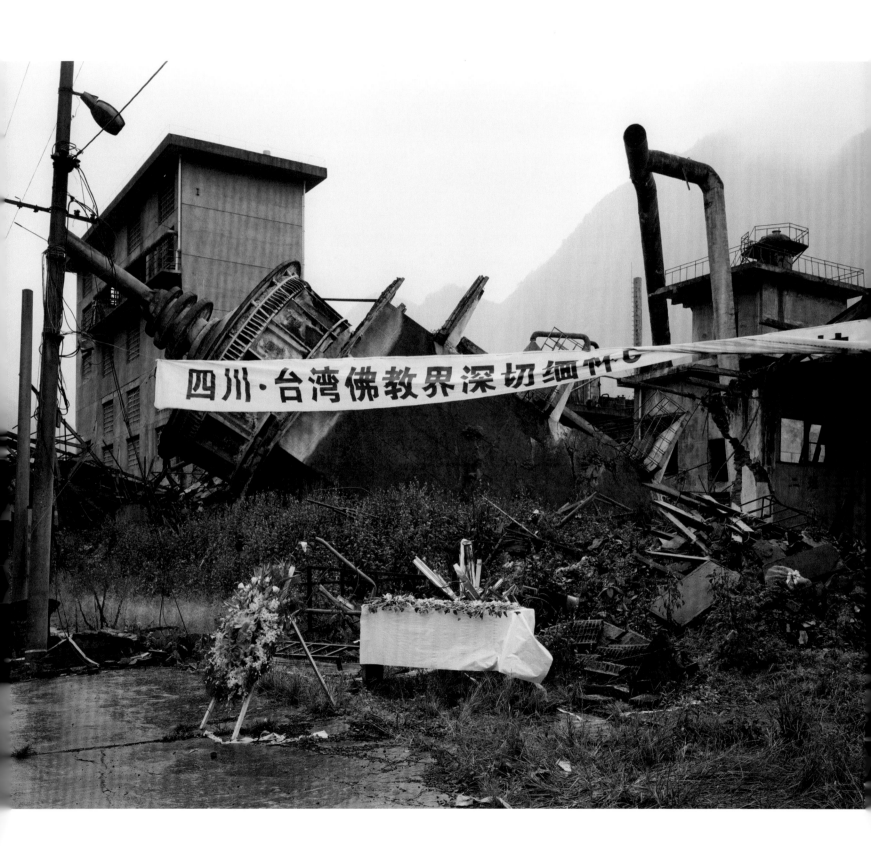

Sichuan Wenchuan earthquake ruins tour
Broken Xiaoyudong bridge, take pictures for Earthquake ruins

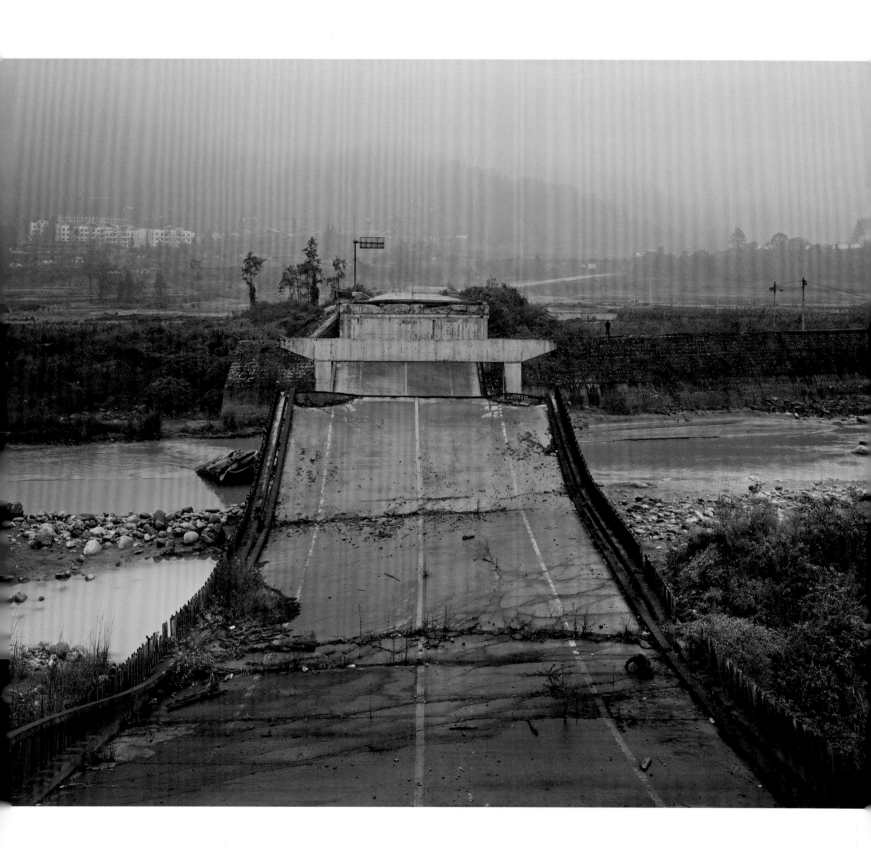

Sichuan Wenchuan earthquake ruins tour
We arrive in Yingxiu town and take pictures for Xuankou middle school
(about 53 died), Xuankou grade school (about 250 died)

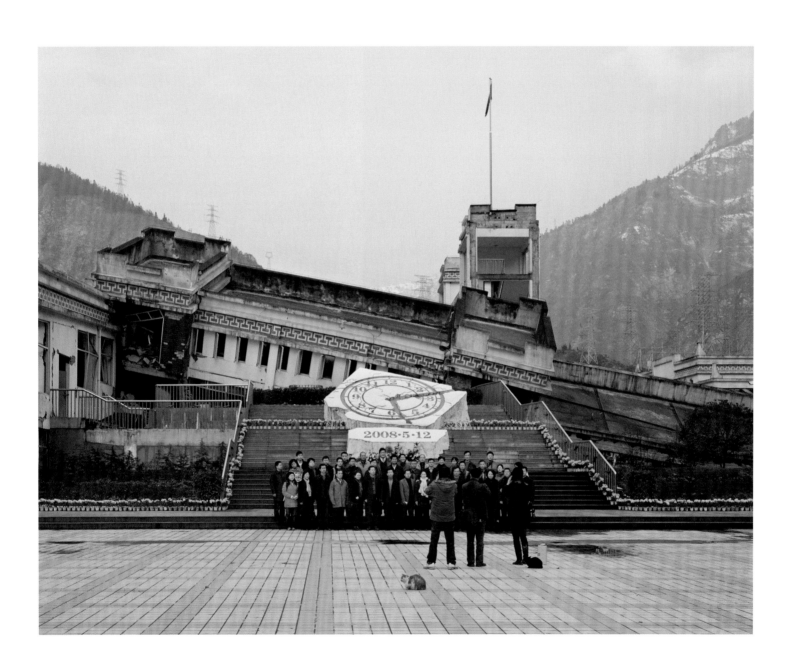

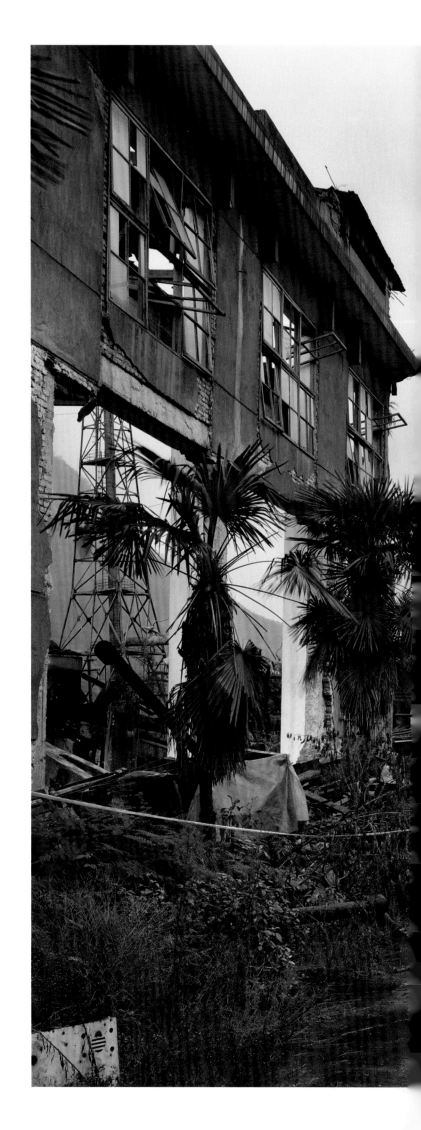

Sichuan Wenchuan earthquake ruins tour
Earthquake Ruins - Shifang (county-level city,
about 5924 died, 214 lost, 33027 wounded)
Sichuan Province, Shihua Stock CO., LTD and
Yinghua stock company

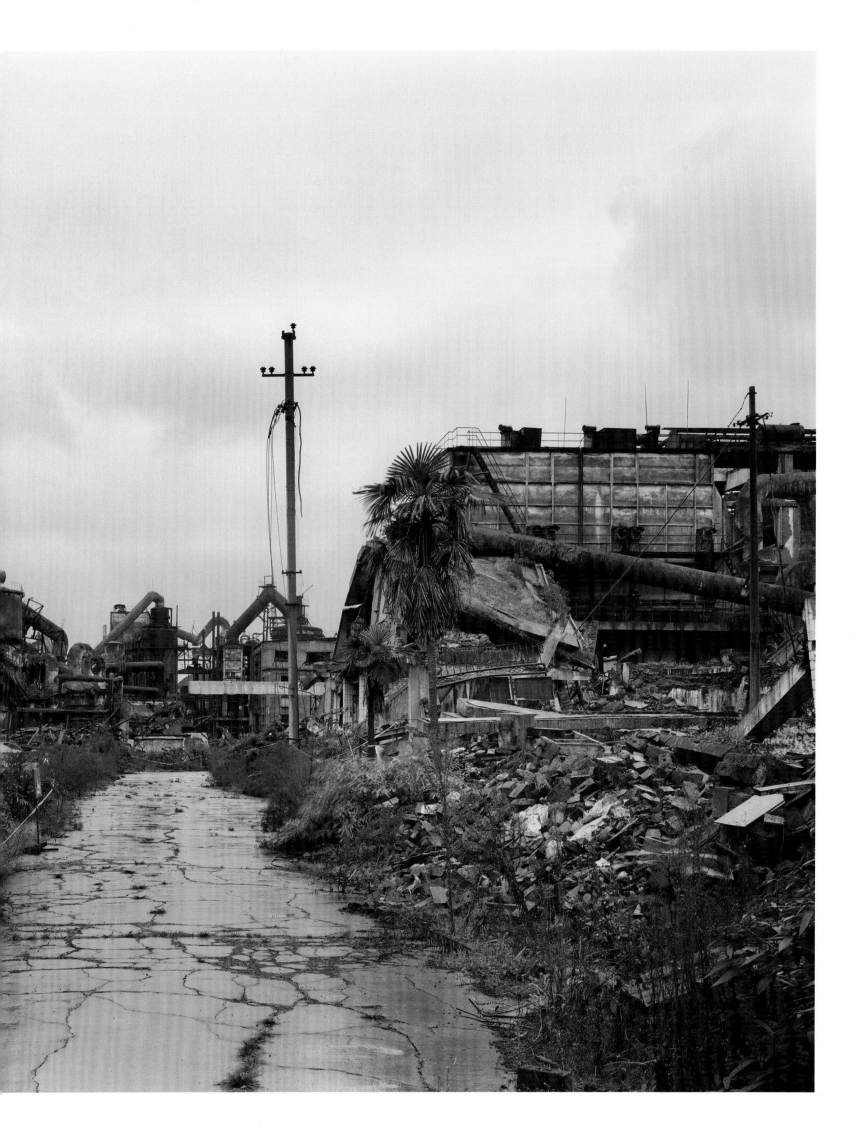

Sichuan Wenchuan earthquake ruins tour
Broken Xiaoyudong bridge, take pictures for Earthquake ruins

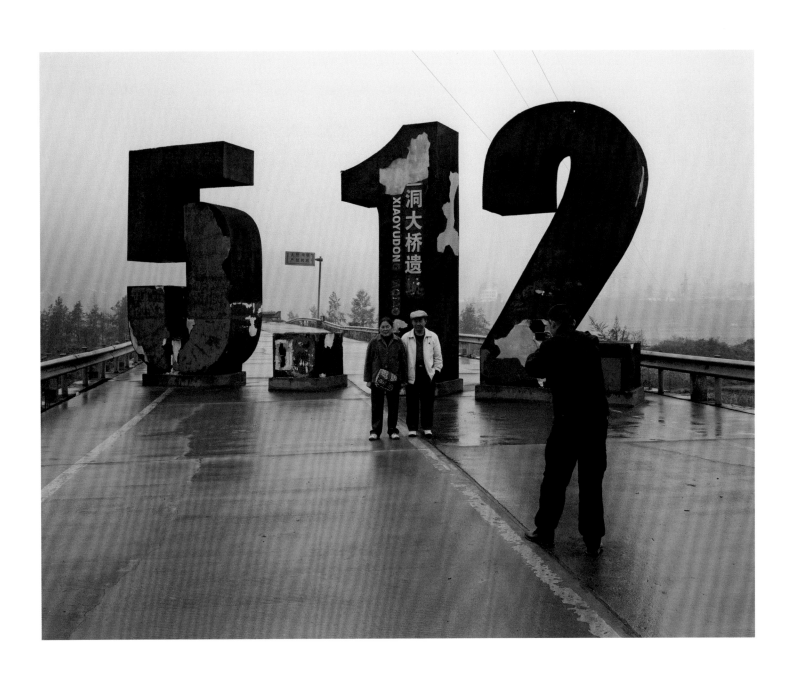

Sichuan Wenchuan earthquake ruins tour
Earthquake Ruins - Shifang (county-level city, about 5924 died, 214 lost, 33027 wounded)
Sichuan Province, Shihua Stock CO., LTD and Yinghua stock company

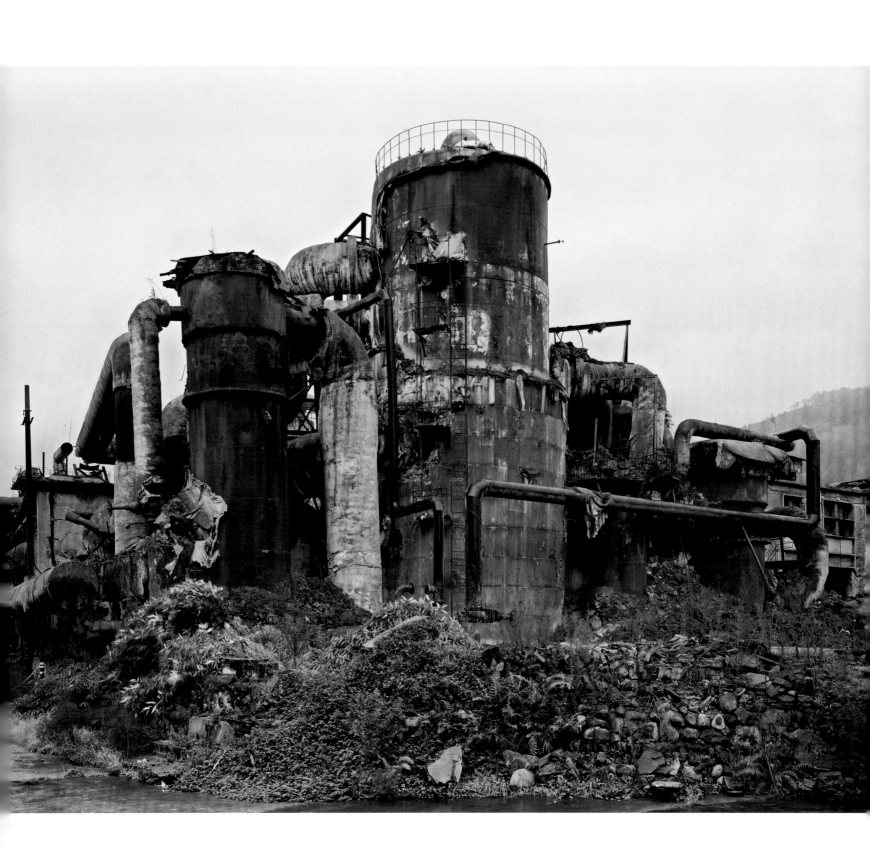

Sichuan Wenchuan earthquake ruins tour
Broken old Hanwang Zhen (Hanwan Zhen is a industry town
about 3000 killed in Wenchuan 5.12 Earthquake)

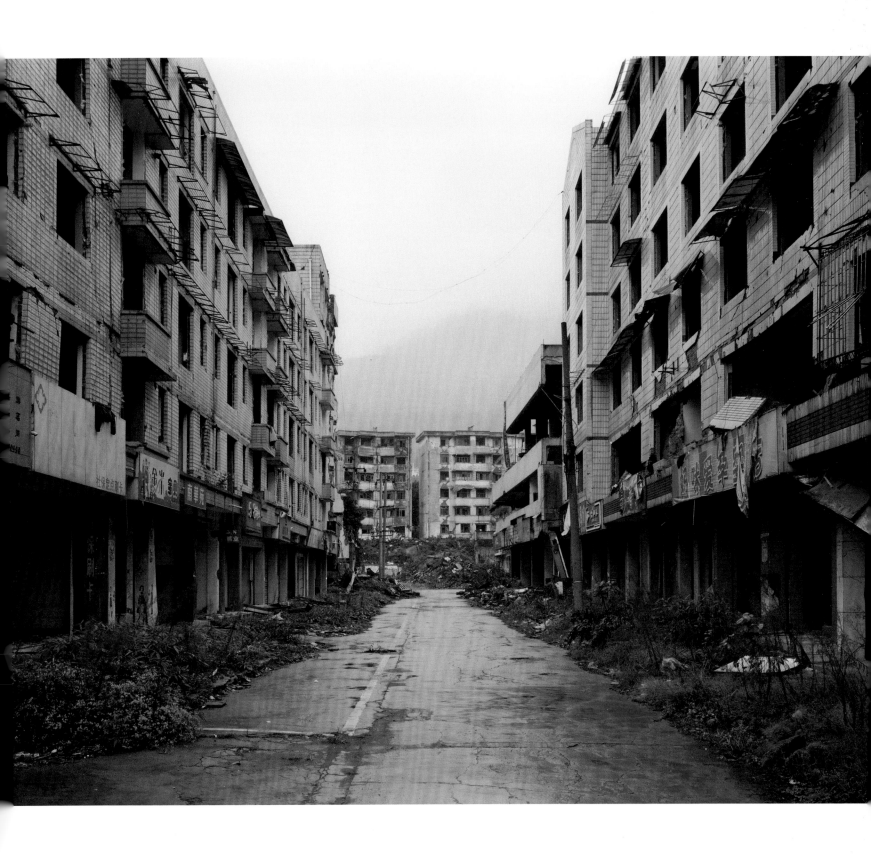

Sichuan Wenchuan earthquake ruins tour
Broken old Hanwang Zhen (Hanwan Zhen is a industry town
about 3000 killed in Wenchuan 5.12 Earthquake)

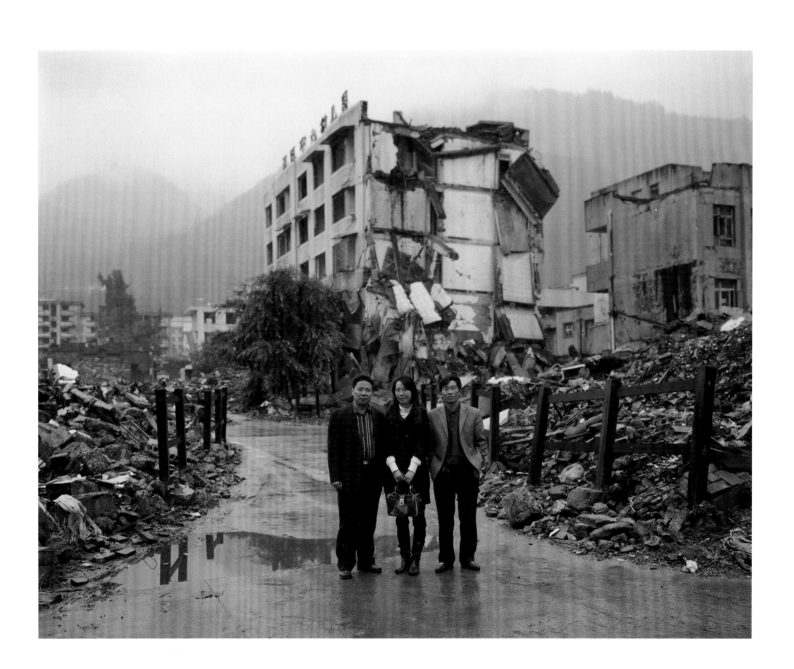

Born in Paris in 1972, Ambroise Tézenas graduated
from the Applied Arts School of Vevey, Switerland in 1994.
His first monograph *Beijing, theatre of the people*,
won the European Publishers Award for Photography in 2006.

Based in Paris, his work appears regularly in major international publications
including the New York Times Magazine and The New Yorker,
and is held in the Bibliothèque Nationale de France public collection.

ACKNOWLEDGMENTS :

My deepest thanks to Professor John Lennon, who offered to share his research on dark tourism. To Mélanie Rio, my gallerist for her commitment to my work. To Lise Sarfati, Sophie Bernard, Damien Peyret, François Adragna and Marc Mawet, for their reading of my photographs and their valuable advice. To Laurent Hutin and Christophe Eon from Lab Janvier in Paris for their long-standing support and masterful prints. To Julie Chazelle for offering to design this book. To Clément Tézenas, the best travel companion ever. To Daphné Hacquard for her invaluable help regarding the texts. To my publishers Dewi Lewis and Benoît Rivero. To my friends and family who offered encouragement and advice. Finally I am also very grateful to my clients and agents for their support which allowed me to finance my personal projects.

This edition first published in the UK in 2014 by
Dewi Lewis Publishing
8 Broomfield Road
Heaton Moor
Stockport SK4 4ND
England

www.dewilewispublishing.com

For the photographs: Ambroise Tézenas
For the introduction and foreword: John J.Lennon and Ambroise Tézenas
For the section introductions and captions: The various sources as quoted
For this edition: Dewi Lewis Publishing

ISBN: 978-1-907893-58-2

Design: Julie Chazelle
Artwork production: Dewi Lewis Publishing
Translation: Emma Lewis
Print: EBS, Verona, Italy